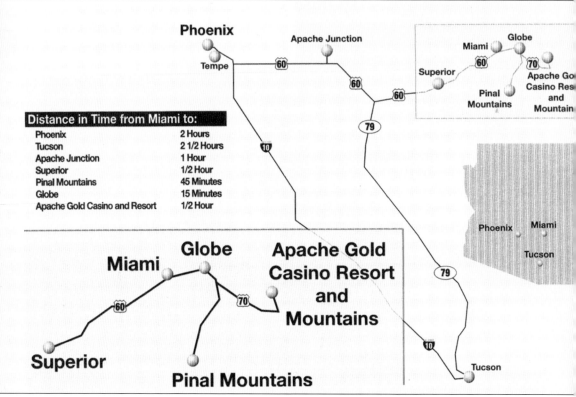

The map shows Phoenix, the state capital, and Tucson, the state's oldest city, founded in 1775 by pioneer settlers from Mexico. Neighbor mining towns Superior and Globe share a long history with Miami in the mining industry of Arizona. In addition, the map shows the location of the San Carlos Indian Reservation, with its Apache Gold Casino, and the surrounding Pinal Mountains. (Map created by Avelardo Moulinet.)

ON THE COVER: Miami, Arizona, pictured in about 1928, gained prosperity from its copper mines, which were in high production before the Great Depression. The photograph shows downtown Live Oak Street looking east, bordered by businesses. The drugstore on the right is one of three in town. The American flag flies over the building, which later became the Safeway Store. (Bill Bell.)

IMAGES
of America

AROUND MIAMI

Santos C. Vega, PhD,
with Marlene Tiede and Delvan Hayward

Copyright © 2011 by Santos C. Vega, PhD
ISBN 978-0-7385-8512-3

Published by Arcadia Publishing
Charleston, South Carolina

Printed in the United States of America

Library of Congress Control Number: 2011929763

For all general information, please contact Arcadia Publishing:
Telephone 843-853-2070
Fax 843-853-0044
E-mail sales@arcadiapublishing.com
For customer service and orders:
Toll-Free 1-888-313-2665

Visit us on the Internet at www.arcadiapublishing.com

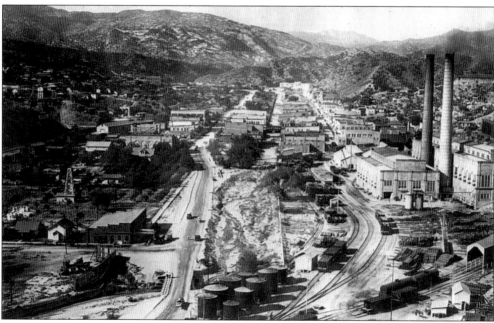

Shown on September 20, 1926, is the two-stack power plant (right). This east-to-west overview photograph of Miami shows the Pinal Mountains in the far west. Included in the picture are the town's two main business streets. Live Oak Street is on the south side (left), and Sullivan Street is on the north side. The town wash in the middle separates both streets, which are connected by bridges. Power plants were fueled at first by oil and later by electricity. (John E. Stearns.)

CONTENTS

Acknowledgments		6
Introduction		7
1.	Place and People	9
2.	Families	23
3.	Celebrations	51
4.	Community at Work	71
5.	Military Service	95
6.	Activities, Education, and Sports	107
Bibliography		127

ACKNOWLEDGMENTS

Thanks to God for all blessings given to the wonderful people of Miami and for making this book possible. This book became a reality because of the generous assistance given by many, from the project's inception through its completion.

Marlene Tiede, proprietor of the Miami bookstore the Book Bank, and Delvan B. Hayward, librarian and administrator of the Miami Memorial Library, both provided space for scanning photographs and interviewing individuals. Images for this book were donated by residents of the Miami-Globe area as well as those who reside in other towns and cities in Arizona and in other states. Donors' names appear with the photographs they contributed to the book.

Thanks go to the Bullion Plaza Cultural Center & Museum's Joe Sanchez, who helped arrange a radio announcement about the project, and Thomas N. Foster, and also to Wilbur A. Haak and Lynn F. Haak, of the Gila County Historical Museum Archive, who offered use of photographs. Special appreciation goes to Mary Pavlich Roby, who submitted information about Croatian, Serbian, and other immigrants from the former Republic of Yugoslavia who settled in Miami. Thanks are extended to Elisa Muñoz, Paul Cruz, Creager and DiAnne Wusich, Caryl Fuller, Mary Anne Moreno, Peggy and Robert Snow, Roberto Reveles, Jesse De Anda, Sammy Muñoz, Sam Echeveste, Sammy Obregon, Fred Ordorica, Bill Bell, Virginia G. Herrera, Eulalio Ballesteros, Linda Pearce, Manuel Torrez, Bob Huggins, John E. Stearns, Paul C. Licano, Otto Santa Ana, David Vargas, Barbara V. Caretto, Rosa Blanco, Raquel R. Gutierrez, Nick and Betty B. Rayes, Juan C. Hernandez, Eddie and Beverly Valenzuela, Lucy A. Rojas, Catalina Valenzuela, Mary Sendejas, and others who expressed support. Thanks also go to Dr. Christine Marin, who accepted the challenges of writing the introduction and editing the book.

Thanks are given to Danny Valenzuela and Anthony Cabrera for their technological assistance, given to me when necessary.

I also thank my former editor at Arcadia Publishing, Jared Jackson, and my current editors Kristie Kelly and Stacia Bannerman for their expert guidance.

Finally, for her love and encouragement on this and other projects, I express my sincere appreciation to my wife, Josie R. Vega, who accompanied me to Miami and took notes.

INTRODUCTION

Approximately 90 miles east of Phoenix and about 100 miles north of Tucson is the copper-mining community of Miami (pronounced, "My-yam-uh," by the more settled of residents there), founded by Cleve W. Van Dyke in 1908. It is a historic and rugged town with its own particular vocabulary: *headframe, tank house, smelter, concentrator, rod plant*, and *slag dump*. Its natural beauty lies in its vegetation—oaks, mesquite, and the palo verde—and in the terrain of the Pinal Mountains that envelope the town. A 4,000-foot elevation invites a winter that sees snow in the majesty of the mountains and a spring season that highlights the beauty of its terrain. And neighborhoods and unincorporated areas nearby have legendary names: Turkey Shoot, Red Springs Canyon, Buena Vista Terrace, Inspiration Addition, Davis Canyon, Wheatfields, Little Hollywood, Mexican Canyon, Claypool, Central Heights, Midland City, Live Oak Street, and Live Oak Canyon. To some, and perhaps to the tourist passing through on West Live Oak Street, this copper town may not seem to be one of beauty at all. Its steep hills are dotted with houses sitting precariously on uneven terrain. Old and abandoned mine structures remain visible from within the town's main street. And a four-foot, reinforced concrete retaining wall built in 1915 to contain floodwaters from the Miami Wash runs smack through the middle of the town.

Anyone can see that the history of Miami is linked to the production of copper; that is still true today. The Freeport-McMoRan Copper & Gold Inc. mining operations remain visible from US Highway 60/70, which brings travelers from the west to Miami. Freeport will begin the development of Miami's first sewage treatment plant, a venture that will bring filtered and purified water to irrigate the community's local golf course. It's a win-win situation for both town and tourists. Cleve Van Dyke's brother-in-law told me that the best thing about living in Miami was that it was perfect for both the rich and the poor. For the rich, the cost of living in Miami was good, and it had many restaurants serving savory and fresh Mexican food to suit any taste. For the poor, the cost of living in Miami was good, and no one would ever go broke there. Cleve W. Van Dyke envisioned opportunities for investments and economic development and had them in mind when he founded Miami Flats, as the town was originally known. He bought the town from other investors for $25,000, homesteaded all its land, and established his own real estate firm, the Miami Trust Company, to manage and control his properties. Major shareholders, managers, and investors in his company included his siblings, his wife and her siblings, his son-in-law and his family, and his close friends who advised him in legal and business matters. Van Dyke laid out the town, plotted it, and graded its streets. He owned the town's public utilities and waterworks, published its newspaper, and named the telephone company after his wife, Ida. The Van Dyke Copper Company mineshaft was built on a hill overlooking the town. Van Dyke's majestic, white two-story mansion and abundant surrounding citrus groves and apple orchards lay below the mine. Many residents today recall stealing apples, oranges, and peaches from Van Dyke's orchards and running away with their prizes to avoid being caught by his gardener and night watchman, a muscular Swede who spoke little English. Today, the Van Dyke presence remains in the town

through an attorney who represents the Van Dyke grandchildren and the 200 parcels the family owns within and adjacent to the town limits.

Soon, more substantial and larger copper companies were established on surrounding hills. A smelter and additional mining structures loomed above the town like monoliths on its mountainsides. The town and its merchants and business owners served the copper industry and mining companies, including the Miami Copper Company, the Inspiration Consolidated Copper Company, the Iron Cap Mine, and the International Smelter and Refining Company. Miami needed workers to mine its copper, and the community soon became an immigrant town—a workers' town—and its population reflected its racial and ethnic composition. In the decade from 1910 to 1920, the town's population rose to almost 10,500 people, an increase from the estimated 1,800 recorded in the 1910 census. Immigrants came from Mexico, the Balkans, Eastern and Northern Europe, China, England, Italy, and Spain. African Americans joined the westward trek too, with many families traveling to Miami from Texas and Oklahoma—all coming to work and live and forge out their American Dream of education and success. They sent their children to the elementary schools in their neighborhoods: Central School, Black Warrior, Bullion Plaza, Thomas Jefferson, Live Oak, Inspiration Addition, Oak Street, Buena Vista, George Washington, and the Benjamin Franklin School on Inspiration Hill (where the mining engineers, prominent and wealthy mining officials, and mining administrators lived). The Miami High School and its faculty and coaches served them all well. All-round athletes in all sports earned athletic scholarships to prestigious universities, and talented students earned educational scholarships that led to academic, law, and business degrees. Students also came away with skills that gained them important and national prestige as labor and political leaders, attorneys, educators, entrepreneurs, physicians, scientists, and university professors: Romana Acosta Bañuelos was selected by Pres. Richard Nixon to serve as the treasurer to the United States in 1971, a post she held until 1974; Estéban Edward Torres was appointed US ambassador to the United Nations Educational, Scientific and Cultural Organization (UNESCO), in Paris, France, from 1977 to 1979, and served as special assistant to Pres. Jimmy Carter from 1979 to 1981; Orville Larson became the vice president of the International Union of Mine, Mill and Smelter Workers (founded in 1916), a class-conscious industrial labor union with a solid record in positive race relations; and Dr. Harold McNair is considered the "icon of modern chromatography," a scientific way of separating a variety of gaseous and chemical compounds, used to help determine the structure of the insulin molecule and in solving mysteries in forensic science.

The immigrant workers brought their religions to the copper town and established their own places of worship in their community. Lutherans, Methodists, Presbyterians, Catholics, Jews, and Mormons brought diversity to Miami and changed the cultural landscape of this copper town. For amusement purposes, the community established the Airdome Theatre in 1912 and brought in vaudeville shows and a variety of musical acts and performers to provide some joy and entertainment to the hardworking miners and their families. By the 1920s, theaters with names like the Unique Theatre and the Gem Theatre soon appeared on Sullivan Street in the downtown area; the Lyric Theatre and the Grand Theatre were built in the later years to feature first-rate American-made movies and also those produced in Mexico. The two local YMCAs and a town swimming pool built in the 1950s offered a variety of recreational opportunities for families and children. Labor leaders built labor unions out of a struggle for fair wages and equality. And they established baseball and softball leagues with players competing against local squads and teams from surrounding copper towns such as Globe and Superior.

This book features the lives and faces of the folks who settled in Miami. Their hard work and their accomplishments and sacrifices in wartime are badges of honor and pride. Their families represent the promise of a future in the American copper town they called home. It is their stories that make this book so compelling and dramatic.

—Dr. Christine Marin, 2011

One

Place and People

The Globe-Miami Baseball Players Reunion was held about once a year. This one occurred in the early 1990s. The Globe-Miami area has a long history of community outdoor sports competition between sponsored teams in softball, baseball, bowling, Little League, and other sports. The area's semiprofessional baseball league featured many teams that competed locally and with teams from California and Mexico. (Samuel Echeveste.)

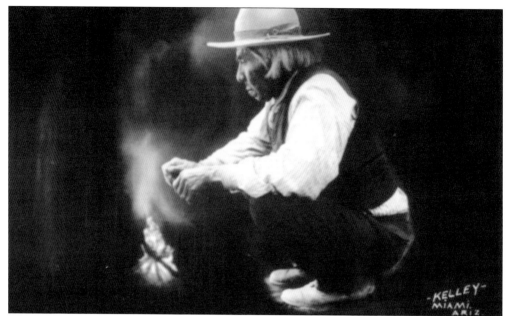

Apache chief Talkalai, pictured at 110 years old, was a scout in the US Cavalry with Gens. Crook, Miles, and Howard. He also served 21 years as police officer on the San Carlos Indian Reservation. Also around Miami is the Fort Apache Reservation (which is government trust land), a Native American area consisting of beautiful lakes and reservoirs and high, mountainous pine country. The Apache people sustained themselves with economic endeavors situated in their vast land holdings. (Photograph by Kelley's Studio, Miami, 1928, courtesy of Joe Sotelo.)

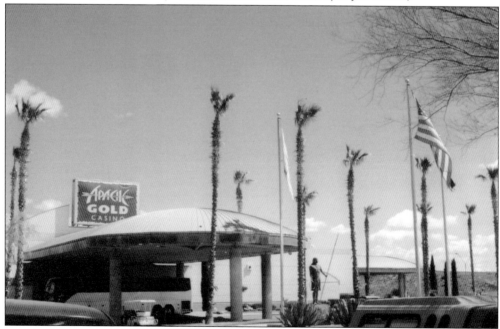

Apache Gold Casino is located three miles east of Globe. Many visitors come to enjoy card games, slot machines, gambling, and eating plenty of food in the buffet and restaurant areas. The Best Western Hotel provides overnight accommodations. (Santos C. Vega.)

Numerous mountains and hills surround Miami. US Highway 60 leads from Miami to Superior and winds its way through the Pinal Mountains. This photograph provides an example of mountain rock formations and brush and saguaro cacti growing on the south side of the road. The drive from Superior to Miami covers 20 miles of this exotic scenery. (Santos C. Vega.)

Besh-Ba-Gowah Museum and Pueblo Archeological Park is located in southeast Globe. The ruins of ancient Native American buildings are preserved, and their burial places are shown. (Santos C. Vega.)

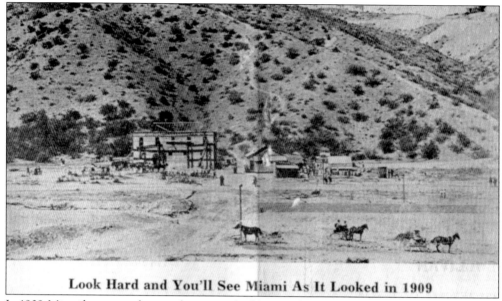

Look Hard and You'll See Miami As It Looked in 1909

In 1909, Miami began simultaneously erecting buildings and constructing mining-related structures, such as a crusher, a concentrator, a mill, and shafts for underground tunnel, drift, and chute excavations at different levels. Construction of the smelter also commenced. Dirt roads connected the workplace with the town. Families lived in tents. The town seemed to race with time to build what yet remained in the future. (Bob Huggins.)

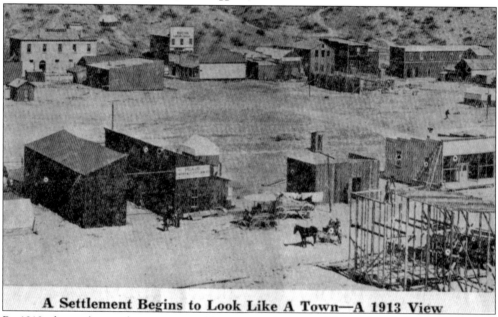

A Settlement Begins to Look Like A Town—A 1913 View

By 1913, the settlement began to resemble an emerging town. Miami, founded in 1907, seemed to grow at once and in spurts. The labor was provided by Welsh, Croatians, Serbians, Mexicans, African Americans, Lebanese, and Spaniards, among others from all over the world. Workers came from several states within the United States as well. Together, they mined the copper, created business enterprises, built homes, and constructed roads that linked all of Miami's economic, social, and educational places. (Bob Huggins.)

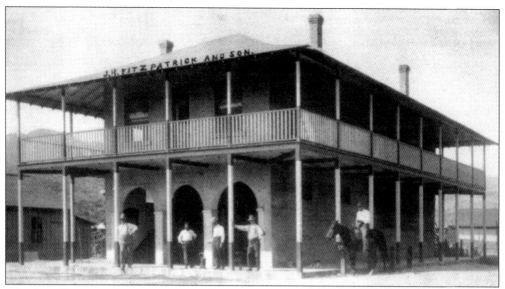

West from Keystone Avenue, on the southwest corner of Gibson Street, stands the J.H. Fitzpatrick and Son Building, constructed in 1909. It is the town's oldest building, and its two-story porch and hipped roof typify features common to many Arizona Territory–era structures. On the premises, a restaurant with bar served food and liquor, held dances, and housed Miami's first bank, which was managed by John Fitzpatrick. (Joe Sotelo.)

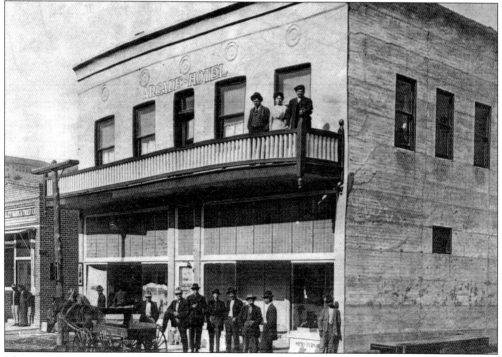

The Arcade Hotel, built in 1920 at Keystone Avenue and Gibson Street, provided lodging for miners and other workers, including large numbers of single laborers. They flooded Miami at a time when few housing units existed. During the 1920s, even the town government occupied rented quarters in the Arcade Hotel. (Creager and DiAnne Wusich.)

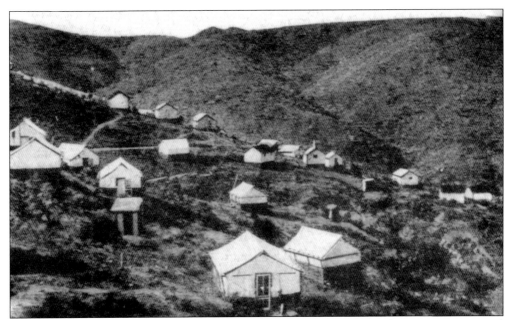

Miami was called the "Tent City" for its lack of wood-frame houses. Residents were encouraged construct their own homes with tents over wooden floors. This image shows the tent homes constructed in Davis Canyon in 1900. (Joe Sotelo.)

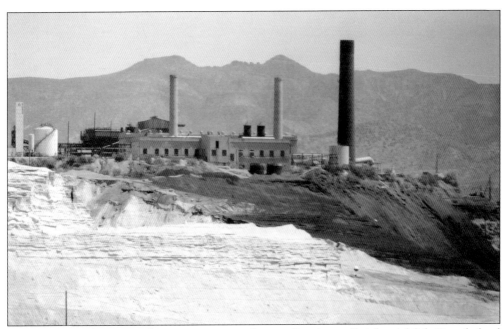

The Miami Smelter power plant was constructed using 42 railcars of bricks. Adelido Perez helped build the powerhouse to run the machinery. Train ore cars carried the mined ore to be loaded into furnaces and smelted. Smelting the ore separated it into the by-products of gold, silver, and copper. Wastes included tailings, white ash, and black slag. The picture shows white tailings and black slag. (Photograph by David Martinez, courtesy of Santos C. Vega.)

Central School, located on a flat, graded area on top of a hill, down from and southeast of the Miami-Inspiration Hospital, was constructed in 1912 and served as Miami's first school. The school and hospital stood on separate adjacent hills, immediately northwest of Red Springs Canyon. Red Springs, later named Chisholm Street, was one of a few streets that were paved with concrete. (Virginia G. Herrera.)

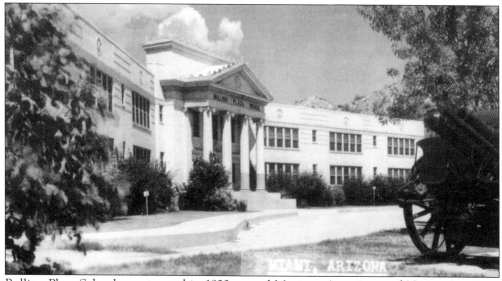

Bullion Plaza School, constructed in 1923, served Mexican American and Native American Apache elementary students who resided nearby on a hill behind the school. A social and cultural segregation mode prevailed until the mid-1950s in Miami. After elementary graduation, all students attended Miami High School. The World War I cannon on the right was donated to the school and used as a historical monument. (Virginia G. Herrera.)

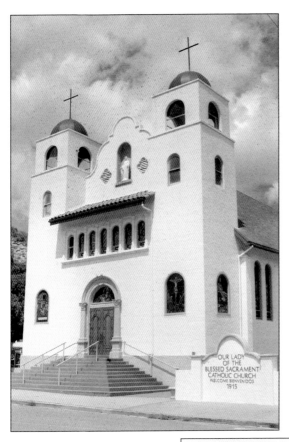

Our Lady of the Blessed Sacrament Church, built in 1915 and located at 904 Sullivan Street, has continuously served Catholics for 96 years. According to the *Historic Resource Survey of Miami*, Our Lady of the Blessed Sacrament Church "is a well-preserved and impressive local example of Mission Revival architecture" in Miami. The church is part of the Arizona Catholic Diocese of Tucson. (Santos C. Vega.)

Divine Grace Presbyterian Church is located at 305 Live Oak Street, on the south side. Known as the Miami Community Church when it was built in 1920, its congregation has existed since 1910. The *Historic Resource Survey of Miami* described this building as a "Mission Revival–inspired structure designed by the El Paso, Texas, firm of Trost and Trost." (Peggy Snow.)

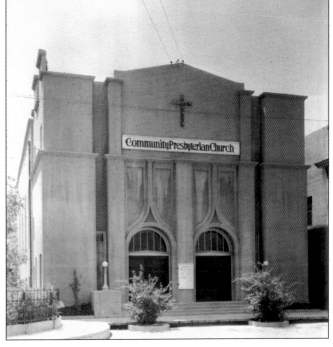

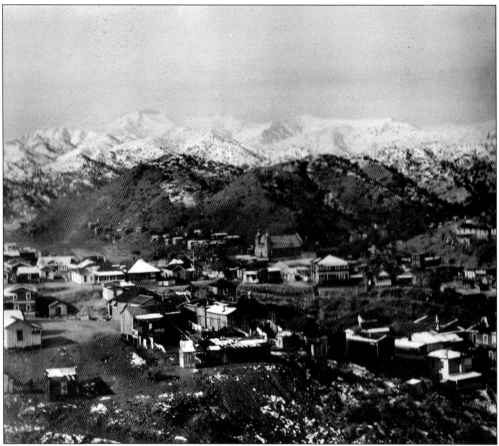

The three main mining operations—Miami Copper Company, Inspiration Consolidated Copper Company, and the International Smelting and Refining Company—materialized from 1909 to 1918. The area had a railroad by 1909. In 1914, the town incorporated as the Town of Miami, and by December 1918, the date of this photograph, it had increased in population to well over 5,000. (Photograph by Price of Humboldt, courtesy of Fred Ordorica.)

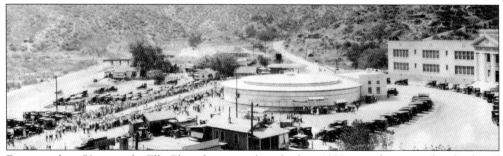

For more than 50 years, the Elks Plaza dance pavilion, built in 1928, served as a social and cultural center for residents in the Miami and Globe area, as well as for visitors who came from other mining towns for weekend dances. Other town activities, such as the Boomtown Spree, occurred here. The dance hall was leased by Anthony "Tony" Gutierrez in 1979 to present musical events and continued as a site for music and dance recreation until 1986. (Elisa Muñoz.)

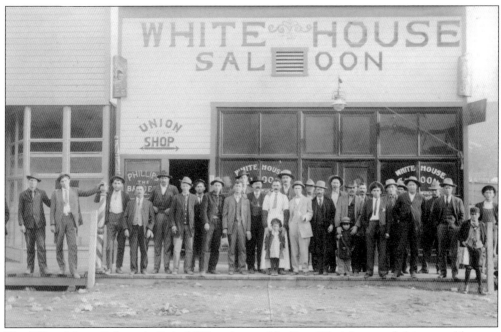

The White House Saloon, built in 1909 and owned by Sam Wusich, served thirsty and hungry miners. Numerous other saloons, bars, taverns, restaurants, and cafés provided employment for residents not working in the mines. The White House Saloon supported the School Spring Festival, as did other civic-minded businesses in Miami. (Creager and DiAnne Wusich.)

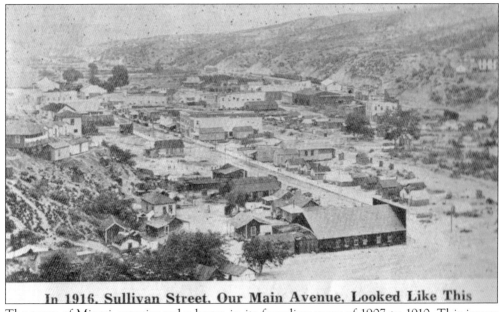

The town of Miami experienced a boom in its founding years of 1907 to 1910. This image shows Sullivan (Miami's main street) and Live Oak Streets separated by the town wash, as the area looked in 1916, seen from west to east. In the early 1940s, "Maestro" Flores operated an automotive repairs garage from the large building (bottom right) near the entrance to Davis Canyon. (Bob Huggins.)

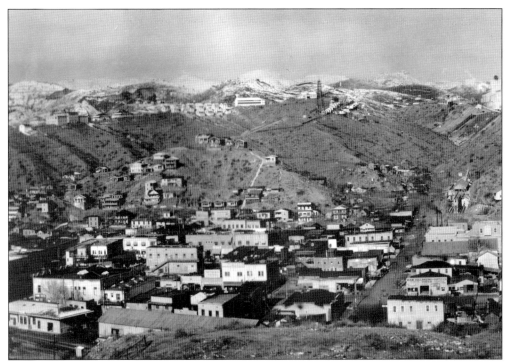

This image presents a 1918 overview of the town, looking south from the northern Depot Hill area. The Southern Pacific Railroad depot (left bottom) fronts Adonis Avenue (not visible), located west of the depot. Adonis leads south past Live Oak Street and meets with Keystone Avenue, whose south end connects to cement stairs. Miners walked up these stairs and followed a trail into a mineshaft that led to underground work. (Fred Ordorica.)

These Miami Copper Company houses are located near mineshaft no. 5. The bottom of the image, dated February 12, 1918, shows a graded area. Miami Copper Company and Inspiration Copper Company constructed company houses for workers near sites of operations. (John E. Stearns.)

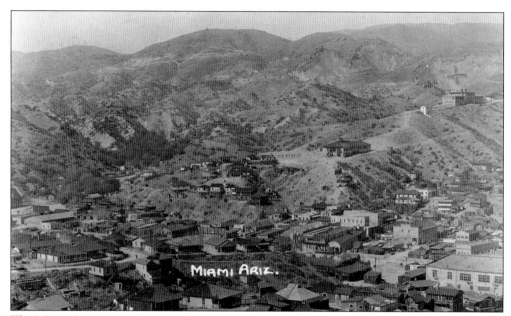

The Miami-Inspiration Hospital (far upper-right corner) was built by Inspiration Consolidated Copper Company in 1912 on a hill adjacent to and west of Red Springs Canyon. A dirt road leads south from it to the Central School built in 1911. The school is west of Red Springs Canyon and northeast of Church Hill. This photograph dates to about 1914. (Bill Bell.)

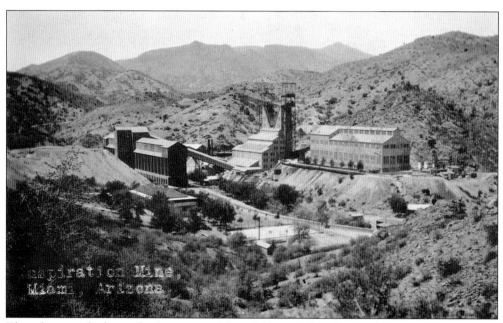

This photograph shows the Inspiration Mine fully completed around the 1920s. About the Inspiration Mine, Isabella Hays, wife of Rhea M. Hays, mother of Wilma Hays, and grandmother of Bill Bell, wrote, "I can see this from my house. Sure pretty at night." (Bill Bell.)

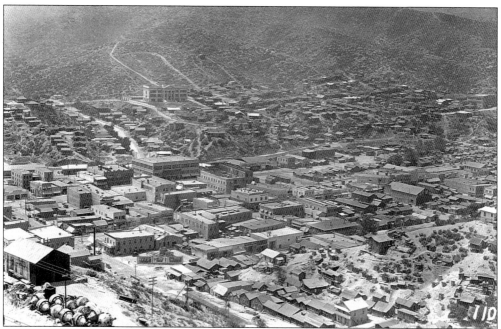
This overview of Miami looks north from the southeast side of the town and shows the Miami High School on top of a mountain. The school, designed by Henry C. Trost of the Trost and Trost architectural firm in El Paso, is a Neoclassical Revival–style building completed in 1916. The photograph is from around the 1920s. (Bill Bell.)

This picture shows the Valley Bank Building (right) on the east corner of Keystone Avenue and Live Oak Street, around the 1930s. In the distance is the flight of concrete steps known as the "Skyline Trail," which lead to the Miami Copper mineshaft; the stairs were built in 1915. The Miami Copper Company Dispensary on the second floor of the bank provided medical services to employees and families. (Bill Bell.)

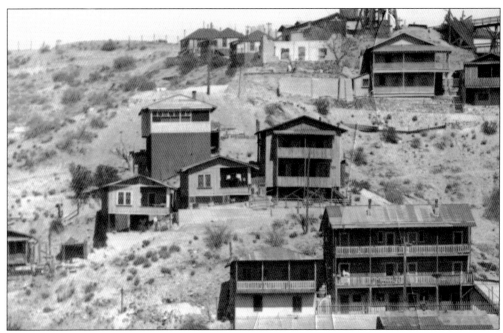

Pictured are examples of the two- and three-story homes built on Church Hill prior to 1939 to provide housing for the rapidly growing population of Miami. Town builders constructed numerous other similar residences on the hilltops of surrounding Miami. The wood-frame homes include porches in the front and pitched roofs that are well-suited for winter snows. (Fred Ordorica.)

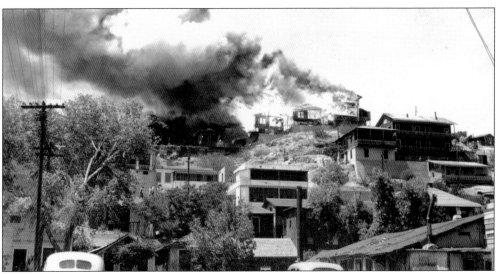

Fred Ordorica's home and other houses near his house burned to the ground. Firefighters found it difficult to drive their trucks up Church Hill to fight the blaze. Lack of water mains on top of the hill presented another problem. (Fred Ordorica.)

Two

FAMILIES

Pictured in Dubrovnik, Croatia, in 1905 are, from left to right, Kate Kordic, Ivo Kordic (father), and Maria Kordic. Kate married a Pavlich, and Maria married a Katalinich. Kate was the mother of Mary Pavlich Roby; Ivo Kordic was Mary's grandfather. Most residents of the Globe-Miami area who have a Slavic background are either Croatian or Serbian. According to Mary Pavlich Roby, the two ethnic groups speak almost the same language, but Serbians use the Cyrillic alphabet, while Croatians use the Latin alphabet. Both Croatia and Serbia have a large percentage of people of the same faith; Serbians are mostly Greek Orthodox, and Croatians are mostly Catholic. Croatia and Serbia are two of the seven republics that once formed Yugoslavia, which no longer exists. Around Miami, Croatians and Serbians are quite good friends. (Mary Pavlich Roby.)

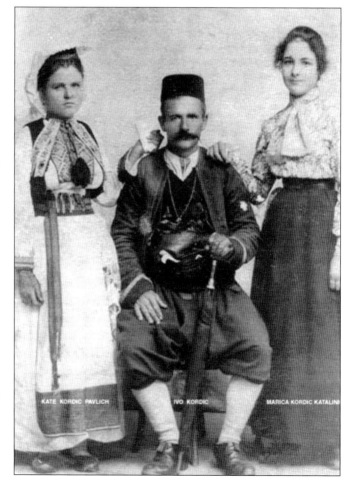

Ivo "John" Pavlich (1877–1932) was born in Kuna, and Kate (Kordic) Pavlich (1884-1980) was born in Gabrili. Both Kuna and Gabrili were villages in a part of Austria that is now Croatia. Ivo's passport indicates he immigrated to America in 1903. Kate Kordic's passport shows she came in 1906. They came from places that changed names. Their city of origin was Ragusa (now Dubrovnik) on the Dalmatian Coast, part of the Austro-Hungarian Empire at the time of their emigration; the area later became part of Yugoslavia, and now is the Republic of Croatia. Although their villages were only 10 miles apart, John and Kate had never been introduced. They met, married, and started their family in Lead, South Dakota. Enticed by the mining industry and appreciative of their freedom, they settled in Miami, Arizona. They were determined to obtain US citizenship, learn English, and provide a formal education for their children. Their children Katherine, John, and Mary all earned college degrees. (Both, Mary Pavlich Roby.)

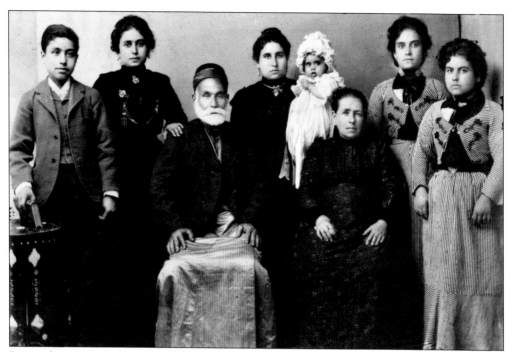

Pictured in 1906, the Rais family, of Damascus, Syria, includes, from left to right, John, Mariam, grandfather Nicholas, Agea with infant, grandmother Nafajeh, Sophia, and Rose. Selim (not pictured), another member of the family, came to America in 1903. (Nick Rayes.)

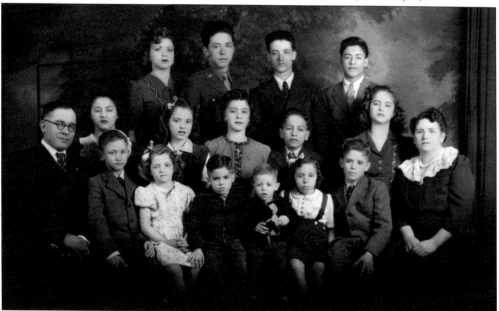

The Aurelio M. and Rosa Johnson Flores family is well noted in Miami. The 15 children participated in education, business, religious, and civic activities for years. Pictured are, from left to right, (first row) Aurelio M. Flores (father), Charley, Stella, Gilbert, Richard, Bernadette, Guadalupe, and Rosa (mother); (second row) Rosa, Josephine, Maria, Jose, and Teresa; (third row) Dolores, Ramon, Albert, and Aurelio (known as "A.J."). (Arlene and A.J. Flores.)

Andres Magdaleno poses at Kelley's Studio on Sullivan Street. He wanted to send photographs to his brother in Aguascalientes, Mexico, and to his sister in Nayarit, Mexico. Andres, born November 30, 1901, in Aguascalientes, worked in a copper mine until an accident ended his life on March 10, 1943. He and his wife, Maria, raised their family in Grover Canyon, Lower Miami. After his death, Maria moved the family to Phoenix. (Rosa Blanco.)

Maria Magdaleno (October 26, 1905–December 24, 1995) is shown in 1959 with her family in Phoenix, 16 years after the children's father, Andres, had died in a mine accident. From left to right are (first row) are Margaret, Rosario (known as "Rosa"), Maria (mother), and Carmen; (second row) Rachel, Mary, Refugio, Jesus, Jose, Lucy, and Teresa. (Rosa Blanco.)

Kenneth Dean Muir, born in 1908, graduated from Miami High School in 1927. He is the father of Caryl Faye. (Caryl Fuller.)

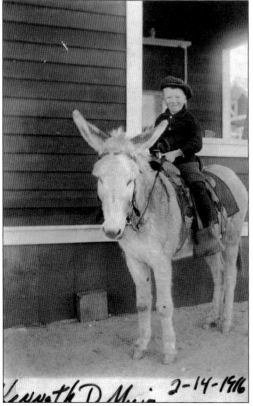

Kenneth D. Muir rides a donkey in Miami in 1916. Although destined for greatness, the mining town, founded in 1907–1910 atop the east central Pinal Mountain range, provided little entertainment for children at that time. It was a period when the itinerant peddlers of a donkey ride and a photograph went from house to house and enticed children to hop on the back of a donkey for a picture. (Caryl Fuller.)

Taken in 1936, this photograph shows the children of the D.O. Norton family. From left to right are Mildred, Melba, Delbert, Leora (known as "Peggy"), and little D.O. Melba went on to become the mother of Caryl Faye Muir. (Caryl Fuller.)

Caryl Faye Muir, pictured at the age of six months, was born on August 29, 1931, in Miami, Arizona. (Caryl Fuller.)

This photograph, taken in the late 1800s, shows D.O. Norton (left), son of Louis B. and Martha Ann Norton. D.O. was the father of Melba Norton and grandfather of Caryl Faye Muir. The man on the right is unidentified. (Caryl Fuller.)

This photograph, taken around 1927, shows Louis B. Norton and Martha Ann Norton, one set of baby Caryl Faye Muir's maternal great-grandparents. (Caryl Fuller.)

29

Elizabeth Dean, from England, and Charles Muir, from Scotland, immigrated to the United States. They married in Colorado, moved to Bisbee, Arizona, in 1908, and later relocated to Miami. They were the parents of Kenneth Dean Muir, born in 1908. Kenneth graduated from Miami High School in 1927. He married Melba Norton, and they were the parents of Caryl Faye Muir, born August 29, 1931, in Miami, Arizona. (Caryl Fuller.)

Charles Muir, pictured at age 24, and Elizabeth Dean were the parents of Kenneth Dean Muir, born in 1908. A photograph of Kenneth Muir riding a donkey when he was eight years old on February 14, 1916, appears on page 27. (Caryl Fuller.)

This photograph, taken around 1917, shows Daniel and Margaret Kendall, the parents of Robert Kendall, the young boy in the picture, who later grew up to become the father of Fr. Daniel Kendall, SJ, who was born in Miami. The young girl, Margaret Alcey Kendall, is Robert's sister and Fr. Kendall's aunt. Years later, in a letter dated August 18, 1931, Margaret Kendall describes conditions around Globe-Miami to friend Lillian Brooks, who had recently moved to Northern Rhodesia (now Zambia), in Africa. Margaret writes, "The town is simply dead. The mines are all operating at a loss." (Dan Kendall.)

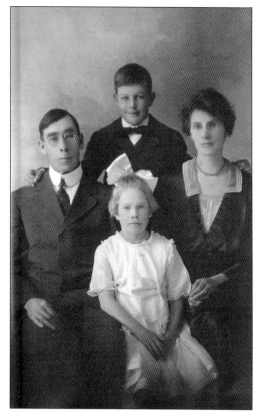

Taken in August 1930 in front of Kendall Insurance Agency and Public Notary in Globe, this picture shows Jo O'Mara (left), Robert Kendall (center), and Margaret Alcey Kendall. On June 7, 1931, Robert graduated from the University of Notre Dame with a bachelor of science degree in commercial science and is the father of Fr. Dan Kendall, SJ, who serves as a professor of theology at the University of San Francisco. (Dan Kendall.)

Juanita Rios emigrated with her family from Puebla, Mexico, in 1910. Juanita (known as "Jennie") had sisters named Rumalda and Belen. Later, Jennie married George Bozovich, who owned Bozovich's International Transit Company, located on the road entering Miami from Superior. He sold it to the school district, which built Bullion Plaza School on the property in 1923. Today, the building is the Bullion Plaza Cultural Center & Museum. (Linda Pearce.)

George and Jennie Rios Bozovich are pictured in 1921 with son Henry, who was born in 1919. Their family home, located at 1218 Sullivan Street, was built on land Bozovich purchased from Cleve Van Dyke in 1911. This is also where Bozovich established his International Transit Company. The company hauled the pews for the Catholic church built in 1915, concrete for bridges constructed over the town wash, and lumber for the Miami High School built in 1916. (Linda Pearce.)

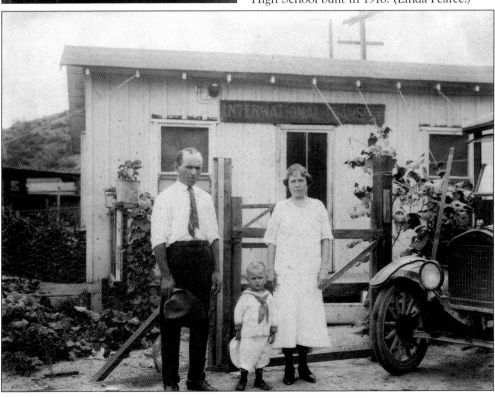

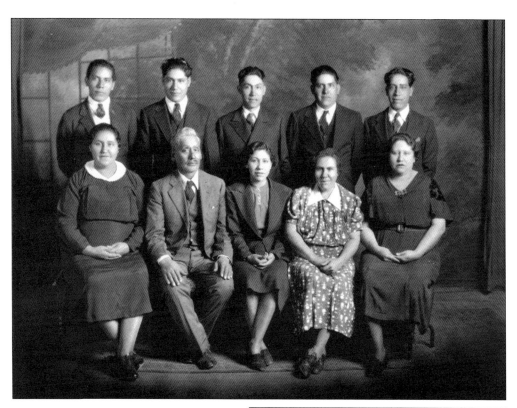

Rudolph Moreno's family is pictured, from left to right, as follows: (first row) Prajedis Rascon Bejarano Moreno (Rudolph's mother), "Papa Roque" Bejarano, Petra Arrellano Bejarano, "Mama Lola" Bejarano, Ricarda "Lala" Laguna Bejarano; (second row) Manuel "Chalo" Bejarano, Francisco Moreno, Juan Moreno, Santiago "Jimmy" Bejarano, and Roque Bejarano. (Rudolph Moreno.)

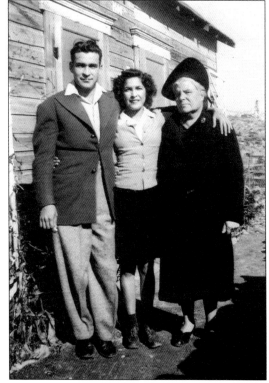

Lucy Archuleta (center), her brother Lucio (left), and their mother, Guadalupe Archuleta, were longtime residents of Miami. Lucy attended Bullion Plaza School and Miami High School. She worked at Becerril's Market for 10 years, then as secretary at Our Lady of Blessed Sacrament Church. Before her retirement in 1986, she worked in the office at Inspiration Elementary School. (Lucy Archuleta.)

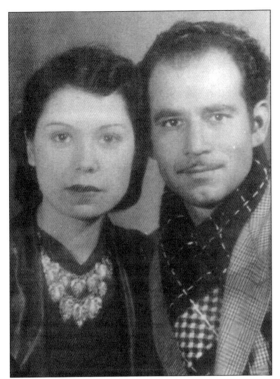

Beatrice "Betty" Portillo (July 3, 1916–December 19, 2005) and Robert Barcon (August 15, 1914–November 12, 1988) married in 1940. As president of the local chapter of the International Union of Mine, Mill and Smelter Workers, Robert used his negotiating skills to help improve unsafe situations and obtain equal wages for Mexican workers. Betty served on the Miami City Council. She and Robert raised one daughter and four sons. (Elisa Muñoz.)

Agripino "A.G." and his brother Amalio Muñoz are pictured as young men wearing boots with tucked-in pants legs and hats. A.G. Muñoz worked for the Miami and the Castle Dome copper mines his entire adult life, spending 17 years as a mine worker supervisor. Amalio worked underground as a driller for the Miami Copper Company. (Sammy Muñoz.)

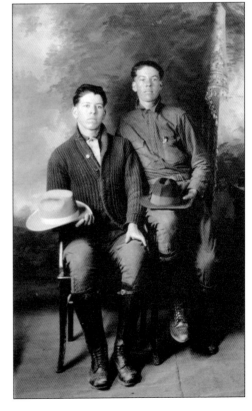

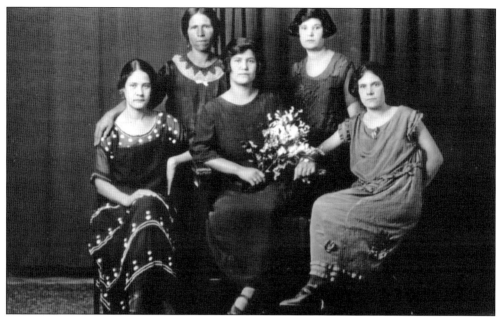

Shown in 1924, from left to right, are Bonilla sisters (first row) Magdalena Martinez, Maria Vargas, and widow Francisca (of Barcon and later of Olivas); (second row) eldest sister Sabas Garcia and youngest sister Guadalupe Muñoz. The five Bonilla sisters crossed the open border with their mother, Teresa Bonilla, in 1902. The Bonilla family later became American citizens. (Elisa Muñoz.)

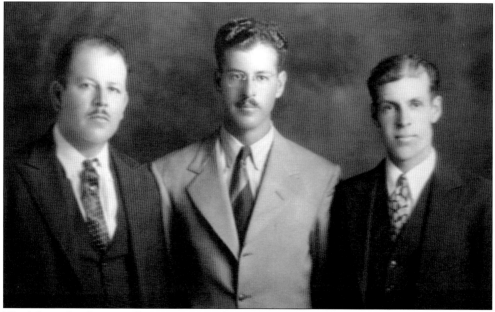

The Muñoz brothers are shown in 1941. They are Agripino "A.G." (left), Ernesto (center), and Amalio. A.G. worked as a miner with Miami Copper and Castle Dome Copper Companies for many years. He was a mine foreman for 17 years; no workers were injured under his supervision. Ernesto served in the US Army and retired as a lieutenant colonel. Amalio worked for the Miami Copper Company. (Sammy Muñoz.)

Ramona Olguin Padilla Echeveste raised her family of four boys and four girls in Grover Canyon in Lower Miami. Her children included Alfonso, Adolfo, Frank, Sam, Carmen, Balbina, Minerva, and Elvira. All children attended Miami schools before the family moved to Phoenix. Families around Miami moved to other parts of Arizona or to other states when the copper mines operated at a loss, jobs were limited, or mines closed. (Sam Echeveste.)

The four Padilla Echeveste sisters are, from left to right, Carmen, Balbina, Minerva, and Elvira. (Sam Echeveste.)

The Echeveste family lived in Grover Canyon, in the Claypool area. The four Echeveste brothers are, from left to right, Sam, Adolfo, Frank, and Alfonso. (Sam Echeveste.)

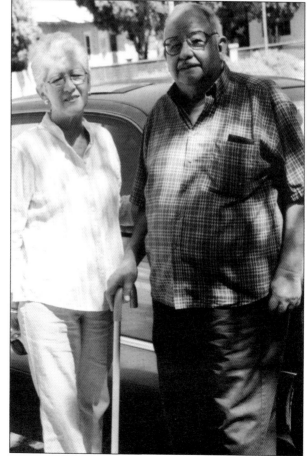

Arlene and her father, Aurelio (A.J.) Flores, are longtime residents of Miami. A.J. owned a hardware store located in the Sullivan Street business district for many years. Arlene worked with the court legal system in Tucson for years. Aurelio also helped the community in social, economic, educational, and political services. (Arlene and A.J. Flores.)

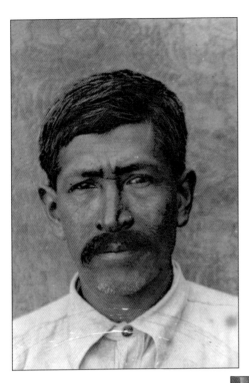

Jose (pictured) and Amelia Armendariz, grandparents of Paul Cruz, came to Miami from Shafter and Marfa, Texas. Quite a few residents immigrated to Miami from Texas to work in the mines. Paul recalls how his grandfather showed him to shoot a rifle and climb hills and mountains. (Paul Cruz.)

Amelia Armendariz, wife of Jose Armendariz, and grandmother of Paul Cruz, is pictured with three of her children (who are unidentified in this photograph). A daughter named Grace was Paul Cruz's mother. Amelia's ancestors emigrated from Spain. She raised her family on Loomis Avenue, also called Turkey Shoot. (Paul Cruz.)

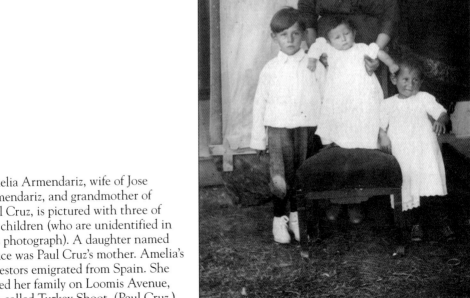

Tony Armendariz and his wife, Connie, pose in about the 1930s. Tony is the son of Basilia Ramirez and thinks one of his mother's brothers may have lived in Ray-Sonora, a mining town south of Superior. Tony is Fred Ordorica's uncle. (Fred Ordorica.)

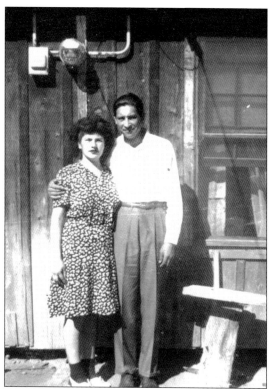

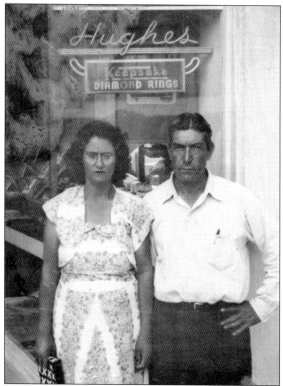

In 1948, Maria and Alfredo Ordorica shopped along Sullivan Street in front of Hughes Jewelry, which was advertising Keepsake Diamond Rings. Alfredo was the father of Fred Ordorica, who lost his mother as a child. Alfredo lived halfway up the Skyline Trail stairs with his wife and Fred's stepmother, Maria. Alfredo came from Mexico in the 1900s and worked underground for Miami Copper Company. (Fred Ordorica.)

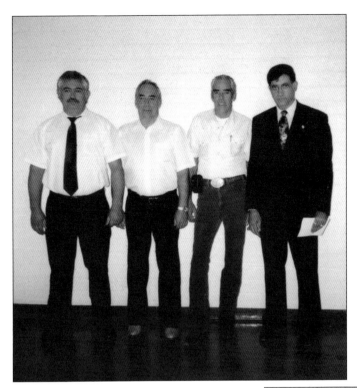

The four Ordorica brothers are, from left to right, Albert, John, Fred, and Frank. The brothers were born in Miami and graduated from Miami High School. Albert graduated from Eastern Community College and worked in Phoenix as a computer technician. John worked as an architectural engineer. Fred was employed by Miami Copper Company and retired from Magma. Frank worked for the Salvation Army and lives in Miami. (Fred Ordorica.)

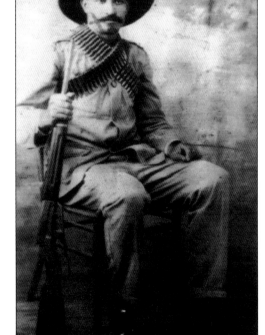

Pictured is Simon Cota, father of Frances Cota. Frances is the mother of Paul C. Licano. Simon, Paul's grandfather, served as a soldier with Francisco "Pancho" Villa in 1915 at Gomez Varillas in Chihuahua, Mexico. Paul served as vice-mayor of the Miami town council. (Paul C. Licano.)

In 1941, the Obregon family lived in Depot Hill; the name derived from its location immediately north of the Southern Pacific Railroad train depot. The Depot Hill housing community occupied the hill east of and adjacent to Adonis Avenue. Shown from left to right are (first row) Rebecca, Benjamin, Esther, and Samuel; (second row) mother Rebecca, baby Rachel, and father Rosario. (Sam Obregon.)

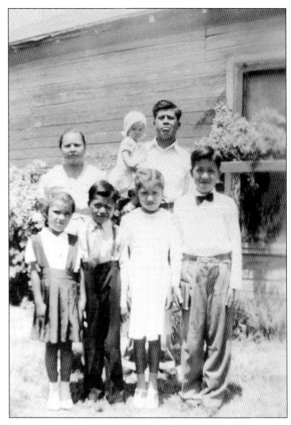

Rosario Obregon graduated from Miami High School on June 4, 1930. He built a replica of the USS *Arizona* battleship while in school. He may have begun his project during his sophomore year and completed it by his junior year. Rosario finished the outer part of the ship with hundreds of matchsticks. He displayed it at Kelley's Studio for a number of months. (Sam Obregon.)

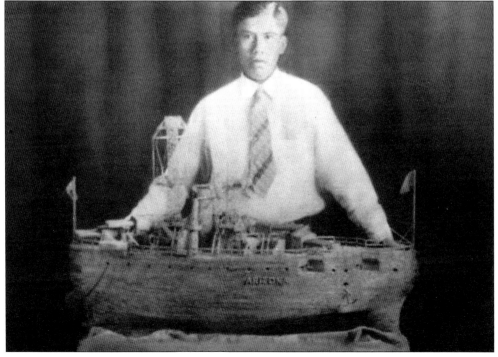

Eduardo G. Herrera, born October 30, 1887, worked in the mines in Miami. He and his wife, Matilde, had eight sons. The family lived in Davis Canyon, and the sons attended local schools. (Virginia G. Herrera.)

Matilde Gradillas Herrera, born March 14, 1897, lived in Davis Canyon. Herrera (left) enjoys a visit with her neighbor friends Vera Almeda (center) and Mona Carrizosa in 1945. (Virginia G. Herrera.)

The Eduardo and Matilde Herrera family lived in Davis Canyon. Matilde raised eight sons, seven of whom served in all branches of the US military from World War II through the Korean War. Pictured in 1998, from left to right, are Herrera sons Johnny, Ernest, Bill, and Reyes. (Virginia G. Herrera.)

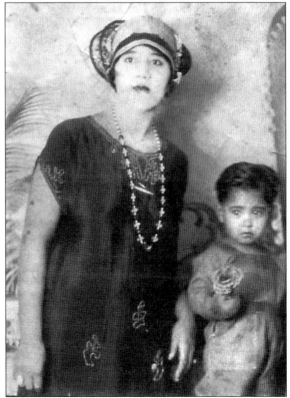

Maria Hernandez met Thomas G. Carbajal after he returned from service during World War I, and they married on September 17, 1921. Their son, two years old in this photograph, was named Arthur H. Carbajal. Later known as Arthur C. Hernandez, he became a professional trumpet player, performing with the dance orchestras of Sipie Martinez, Gilbert Mora, and Waldo Varela, mainly in the Bullion Plaza Ballroom. (Arthur C. Hernandez.)

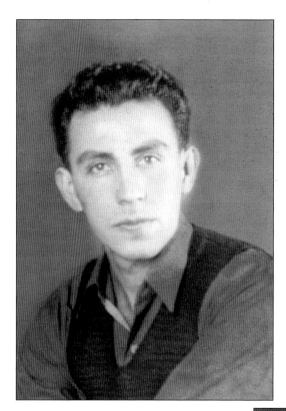

Elias C. Vargas (July 20, 1913–May 28, 1977), patriarch of the Vargas family, is pictured at age 21. Born in Chihuahua, Mexico, Vargas worked as a miner for the Miami Copper Company. He lived to be 64 years old. (David Vargas.)

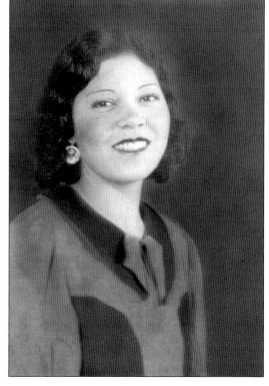

Ysidra Renteria Vargas (May 15, 1917–February 21, 2004), pictured at age 16, was the eldest daughter in her family. She was born in Brice, New Mexico, and married Elias Vargas on July 10, 1933. They had seven children named Richard, David, Barbara, Robert, Frank, Eleanor, and Larry. Elias and Ysidra provided a home for their children on Loomis Avenue, better known as Turkey Shoot. (David Vargas.)

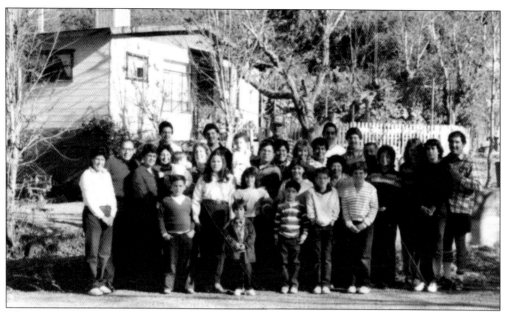

The Vargas family is pictured on Thanksgiving Day around 1983. They are, from left to right, (first row) Ryan (little boy in jacket), Michael (striped shirt), Matt (wearing glasses), and Adam (striped, V-neck shirt); (second row) Jimmy Caretto (V-neck shirt), Stephany Caretto, Bethany (holding football), Britney, grandmother Ysidra, Stella (striped shirt, dark hair), and Vanessa (dark shirt); (third row) Ellie (white shirt), David, Helen, Anna (holding baby Carrie), Lark, (holding Jay Robert) Frank, Barbara Caretto, Vicki, Larry (dark hair), Dick (short hair), Kay (striped shirt, light hair), and Bob (plaid shirt); (fourth row) Tim, James, James Caretto (cap), Lenny, and Kenny (Miami sweatshirt). The last name is Vargas, except when Caretto is noted. (David Vargas.)

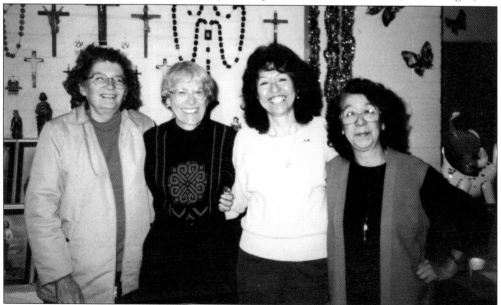

Pictured in 1995 at the Blessed Sacrament Catholic Church's Our Lady's Fiesta religious goods booth are, from left to right, Kathleen Carevich, Betty Beneteau, Emily Licano, and Emilia Almaeda. (Betty Beneteau.)

Pictured in 1996, Armida "Amy" (Yniguez) Huerta, class of 1954, and Manuel "Longie" Huerta, class of 1950, attend the multiple-class Miami High School Reunion at Mesa, Arizona, in the Hilton Hotel. (Manuel Huerta.)

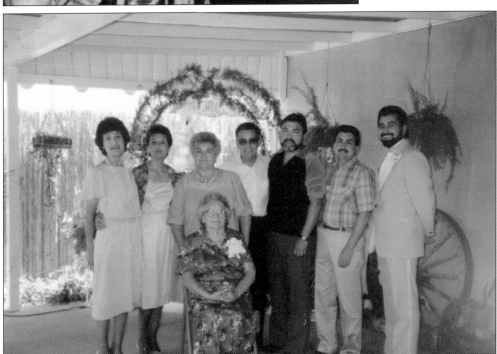

The Yniguez family celebrates the wedding of family members Doreen and David, on August 30, 1986, in California. In the group picture with their mother, Adela (sitting), are the brothers and sisters. They are, from left to right, Linda, Amy (Yniguez) Huerta, Josephine, George Ramirez, Basil, Bobby, and Bennie. Ramirez is one of the brothers. (Manuel Huerta.)

Fortunato Vega was born in Sinaloa, Mexico, in 1875 and immigrated to the United States at age 19. He worked in the United States for 38 years. In Arizona, he labored in the construction of the early roads from Miami to Superior through the Pinal Mountains, and he worked on the building of the Roosevelt Dam. (Santos C. Vega.)

Vicente R. Valenzuela and his wife, Catalina C. Vega, liked to work on arts and crafts made of tin, wood, cloth, or other materials. They gave away or sold their artistic creations to family and friends. (Catalina Valenzuela.)

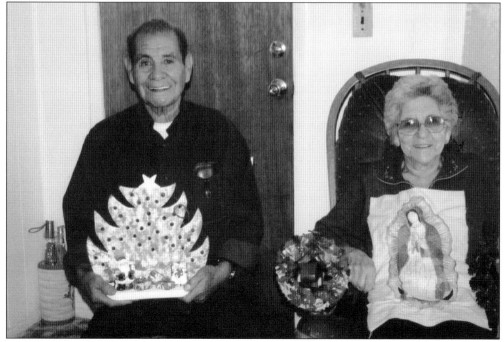

Shown in about 1915, Manuela Granado Carbajal, born in 1880 in Clifton, Arizona, and mother of Antonia C. Vega and Thomas Carbajal, lived and worked in Miami. (Santos C. Vega.)

Antonia C. Vega, born 1895 in Morenci, Arizona, came to Miami in 1915. Here, she poses with her granddaughter Martha Valenzuela. (Catalina Valenzuela.)

Elizabeth Burch came to Miami in 1946 from Portland, Oregon. She supported herself and her two daughters Tamsin Hellem and Delvan Burch by working at the Grand Theatre and later at the Miami Inspiration Clinic and Hospital. Located on the second floor of the Miami Valley Bank Building in the early 1950s, the Miami Inspiration Health Dispensary served mine employees and their families. (Delvan Hayward.)

Elizabeth Burch and her daughter Delvan enjoy dinner at a Knights of Columbus event. Delvan is 12 years old in the photograph and was a student at Bullion Plaza School. Born in Fort Sumner, New Mexico, Delvan moved to Miami with her mother, and she graduated from Miami High School in 1964. (Delvan Hayward.)

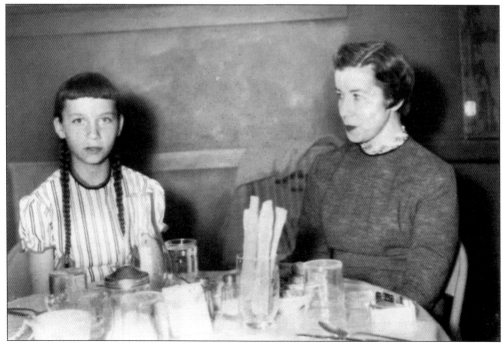

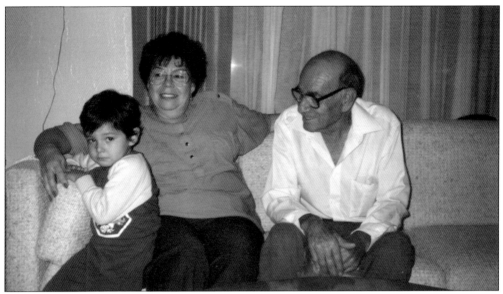

Elisa O. Muñoz and her brother Robert Barcon care for John Richard Perez, Robert's grandnephew, around 1975. Elisa graduated from Miami High School in 1946, and she worked in the aerospace industry in California. Robert gained respect and recognition in Miami for his dedication to improving copper mine safety, working conditions, and other worker benefits while serving as president of the International Union of Mine, Mill and Smelter Workers Local 586. (Elisa Muñoz.)

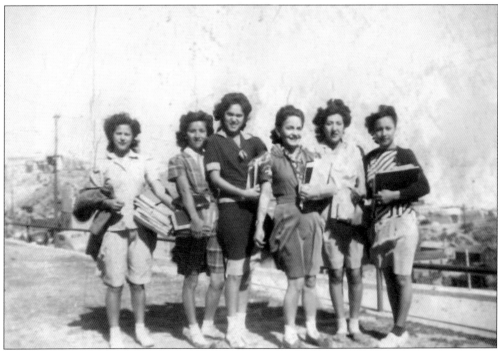

Miami High School students took a bus to school or walked up and down the hill trails. In the spring of 1944, a group of school friends poses for a picture during a walk from the school. From left to right are Rosario Magdaleno, Carmen Sanchez, Mary Trujillo, Olga Armendariz, Lupe Sanchez, and Julia Hernandez. (Rosa Blanco.)

Three

CELEBRATIONS

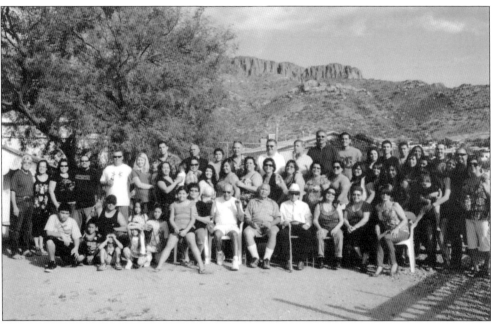

A historic scene—the legendary Apache Leap Mountain crowned by cumulus clouds—served as the place for the Eulalio "Lalo" Ballesteros 2010 family reunion celebration. The setting is at the town of Superior, the site of Magma Copper Company, the world's longest underground mine. Apache Leap is where Apache warriors leaped down to their death rather than surrender to the US Cavalry. Lalo's family settled in Miami in the 1920s, just 20 miles east of Superior. A palo verde adorns the pose of a happy bunch; unfortunately, there are too many in this group to name. A few members of Lalo's immediate family appear in the first row. Lalo is sitting center, wearing a light shirt, without sunglasses. Lalo's brother Gilbert appears left of Lalo, with sunglasses, and brother Rudy is to the right of Lalo, with a cane and sunglasses. Next to Rudy are Lalo's sister Katy and Lalo's wife, Maria (second from right). Lalo's nine-year-old granddaughter Violet is sitting on the lap of a female family friend, immediately to the left of Gilbert. (Eulalio Ballesteros.)

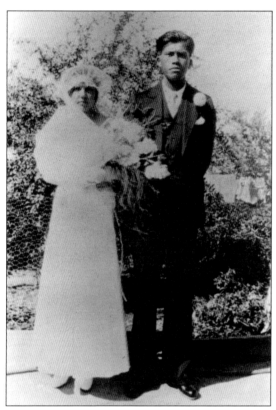

Rebecca Olivas (left) and Rosario Obregon were married on October 17, 1931, in Miami, Arizona. Rev. Sotero Mageno, of the Miami Divino Salvador Presbyterian Church, performed the wedding ceremony. (Sam Obregon.)

Rebecca (Olivas) Obregon and Rosario Obregon celebrated their 50th wedding anniversary on October 17, 1981, in Oakland, California. (Sam Obregon.)

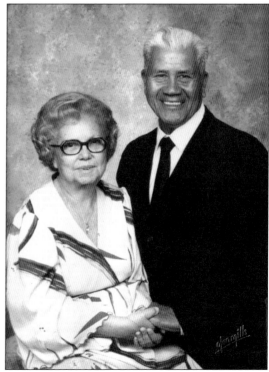

Saad and Rose Raies celebrated their wedding day in Toledo, Ohio, in 1917. Saad and Rose, parents of Nicholas "Nick" Rayes (or, Raies), years later moved to Miami and participated in business. The Raies family lived in Globe in a house built in 1910 of California Redwood and renovated by the Upton family in 1912. In 1938, the property was restored as the Raies family home, where Rose raised her six children. (Betty and Nick Rayes.)

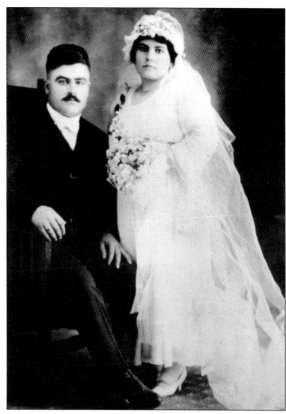

Nick Rayes and Betty (Beneteau) Rayes were wed at the altar of Our Lady of the Blessed Sacrament Church in Miami in 1983. (Betty Beneteau Rayes.)

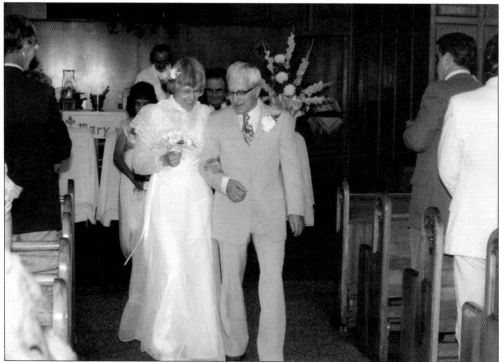

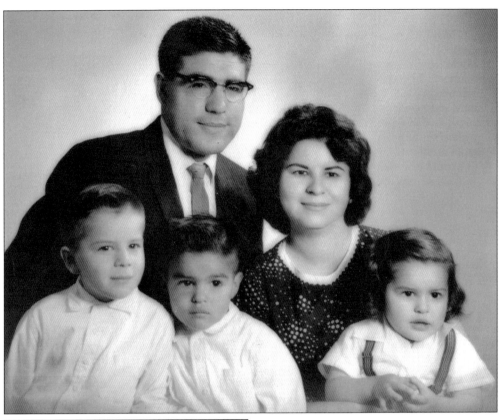

Santos C. (left) and Edilia Garnica Vega pose for a family photograph with their three sons—(Jude Tommy, Anthony, and Carlos in 1961. (Santos C. Vega.)

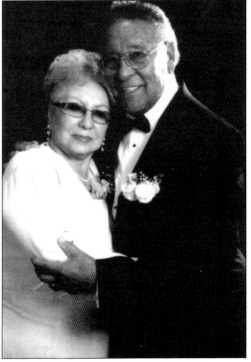

Arthur C. Hernandez and his wife, Anita, celebrated 57 years of marriage. Their family includes two living adult sons, two deceased sons, seven grandchildren, and two great grandsons. Arthur, born in Miami, now lives in California with Anita. (Arthur C. Hernandez.)

In 1924, Guadalupe Bonilla (left) and A.G. Muñoz married in Globe, Arizona, at the Holy Angels Catholic Church. (Bertha Muñoz Sanchez.)

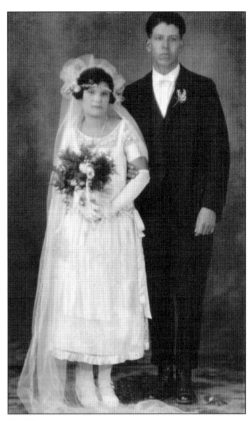

Gloria Sanchez (left), sister of the groom and bridesmaid, along with A.G. Muñoz (far right), the brother of the bride and best man, give affirmation to the 1952 wedding of Bertha Muñoz and George Sanchez. Both bride and groom are Miami High School graduates. George was drafted into the US Army in 1951, served one tour of duty during the Korean War, and returned to Miami to attend college. He became an optometrist and has a practice with locations in Tempe and Miami. (Bertha M. Sanchez.)

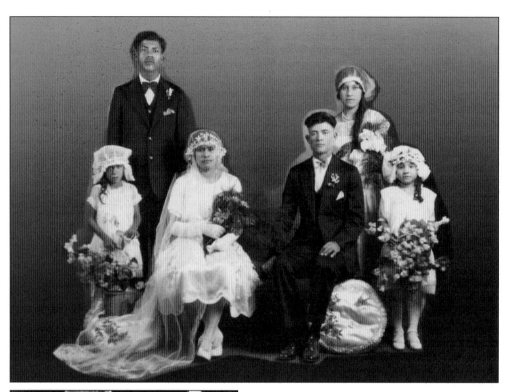

Seated are bride Ramona Obregon and groom Jose Jimenez at their wedding in June 1930. Standing (left) is Rosario Obregon, brother of the bride and best man. The other members of the wedding party are unidentified. Rosario and Ramona graduated from Miami High School in 1930. Rosario is Sam Obregon's father, and Ramona is his aunt. (Sam Obregon.)

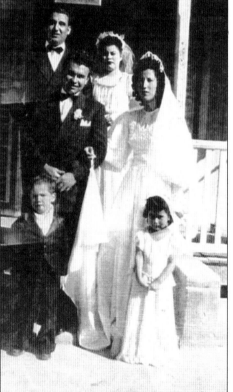

From left to right are ring bearer (first row) Eddie Ramirez and flower girl Jean Ballesteros; (second row) groom Manuel Ballesteros and bride Alice Soto; (third row) best man Manuel Ortiz and bridesmaid Angie Ballesteros. Father Weber performed the wedding at Blessed Sacrament Church in 1948. (Eulalio Ballesteros.)

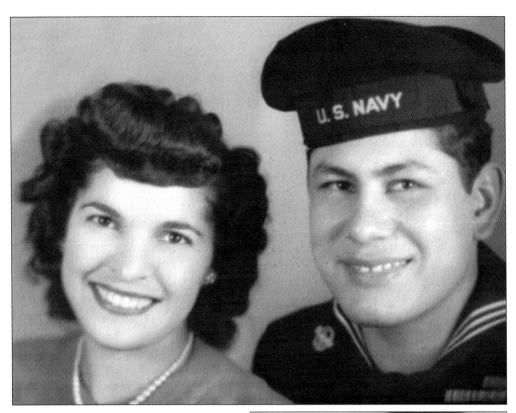

Lucy Archuleta and Arnold Rojas married in 1945, during World War II. After the war, they settled in Miami. Arnold worked for Inspiration Mine for 42 years. Lucy worked at Becerril's Market for 10 years and as a secretary for Father Laroque at Our Lady of the Blessed Sacrament Church. Arnold served as president of the International Union of Mine, Mill and Smelter Workers. Arnold retired in 1985, and Lucy retired in 1986. (Lucy Rojas.)

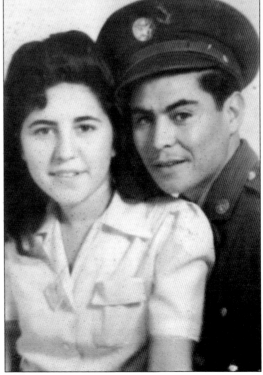

Catalina C. Vega and Vicente Valenzuela married in 1942, during World War II. They celebrated 60 years of marriage and raised their family of four children—Martha, Danny, Irene, and Eddie—in Miami. After the war, Vicente worked for the smelter, participated in community softball sports, and was active in the Veterans of Foreign Wars (VFW). Catalina created arts and crafts. (Catalina Valenzuela.)

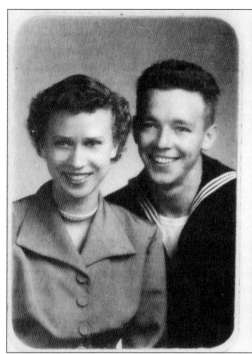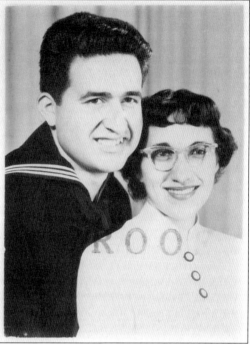

On the right are Manuel Torrez and his wife, Anna Ruth Oviedo Torrez, who married in 1951 and celebrated 59 years of marriage. They had six sons and one daughter, Linda Ruth. On the left are Linda Ruth Torrez Valencia and her husband, Mark Valencia. (Manuel Torrez.)

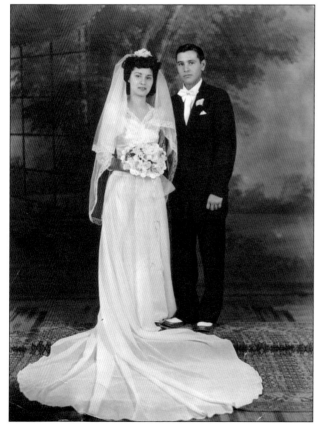

Frances Chavez and Joe Sotelo married in 1943, at Our Lady of the Blessed Sacrament Church in Miami. People knew them well in the community, as Joe made a living from financial accounting, and at one time, they owned and operated a Mexican restaurant on Sullivan Street. He also helped young Boy Scouts as a scoutmaster, holding meetings at Bullion Plaza School. (Joe Sotelo.)

Jennie Rios poses for a wedding-day picture before her marriage to George Bozovich. They had three children: Henry in 1919, Rosalyn in 1921, and Nick in 1924. George emigrated from Budva, Serbia, in 1909. Jennie came to the United States from Puebla, Mexico, in 1910. George prospered and established his International Transit Company and later owned and operated a secondhand-goods store. (Linda Pearce.)

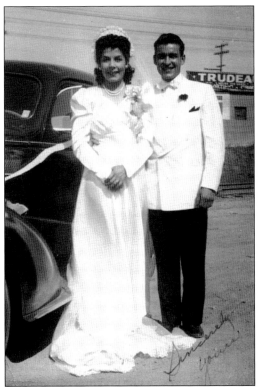

Sylvia Jimenez Almeyda and Alfred Almeyda married in 1947 and moved to California to live and work for several years. They returned to Miami to retire in 1985. Sylvia continues to live in Miami. Alfred died in 1996. (Sylvia Jimenez Almeyda.)

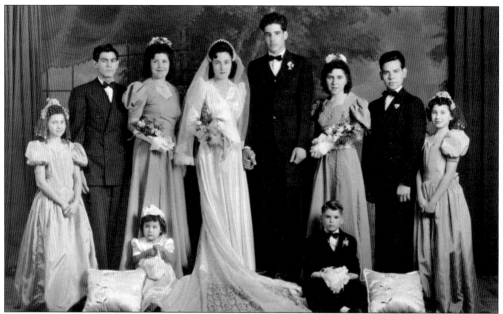

Humberto Padilla and Martha Reade celebrated their wedding in October 1943 in Miami. Pictured standing are, from left to right, unidentified, Danny Aguilar, Olivia Padilla, Martha Reade, Humberto Padilla, Catalina C. Vega, Felix Bracamonte, and unidentified. The young ring and flower bearers are unidentified. (Catalina Valenzuela.)

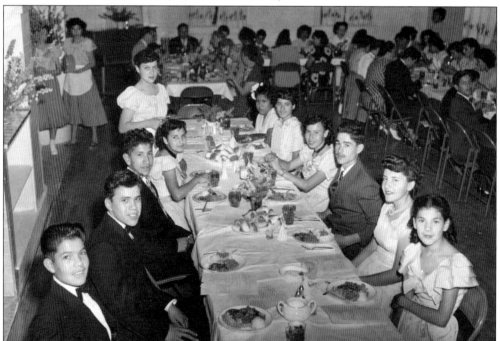

The Bullion Plaza School PTA sponsored the eighth-grade class graduation banquet around 1952. From front to back are (left side) Johnny Rubalcava, Richard Van Order, Ignacio Falquez, and two unidentified girls; (right side) Violeta Benitez, unidentified, Martin Rodriguez, two unidentified girls, and Feliz Reyes. (Paul Licano.)

In 1923, Johnny and Katie Pavlich, children of immigrant parents, had to learn English. Their sister Mary tells this anecdote, "When Katie attended her first day at Central School, she was sent home because she spoke only Croatian. But her mother took her back and, in her broken English, told the teacher, 'you put-ee her in corner . . . her sit-ee . . . her listen-ee . . . her learn-ee.' Little Katie sat, listened, and learned. Katie was salutatorian in her MHS graduating class and valedictorian in college." (Mary Pavlich Roby.)

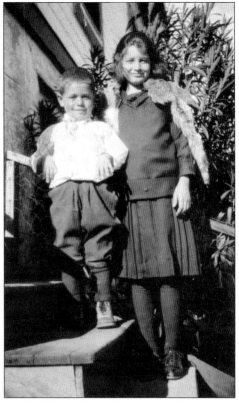

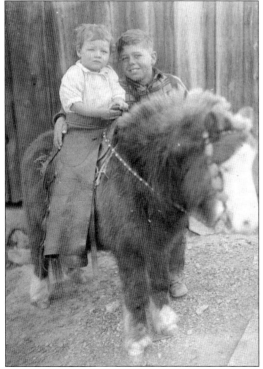

The Shetland pony peddler made the rounds throughout neighborhoods, seeking children to ride the pony. In this picture, taken in 1927, Mary "Margo" Pavlich is on the pony. Johnny Pavlich makes sure his little sister does not fall off. Later in life, Mary became a college professor, and John Pavlich became a well-known and successful football coach at Globe High School. (Mary Pavlich Roby.)

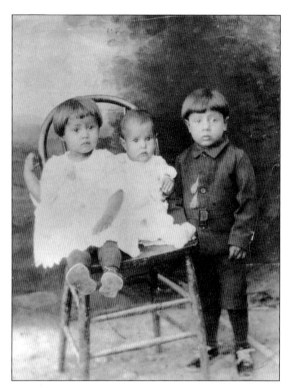

Andres and Maria Magdaleno raised their family in Claypool's Grover Canyon. In 1926, a street photographer came to the house to take pictures. Maria wanted a picture of her children to send to her father in Santa Maria, Jalisco, Mexico. From left to right are two-and-a-half-year-old Carmen, one-year-old Rosario, and four-year-old Jose. (Rosa Blanco.)

Pictured in front of their house, located in Red Springs Canyon, Miami, are Gene Lopez and his baby boy Gene. Not pictured is the baby's mother, Mary Huerta. (Manuel Huerta.)

Sam Wusich, pictured in 1924 with sons Steve (left) and Nick Wusich (right), left his Serbian Orthodox family in Yugoslavia and came to work in the copper mines in Jerome, Arizona, and later in Miami. Sam, an active businessman, owned the Arcadia Hotel with partner Degport. Sam also owned the White House Saloon in 1909 and the Mercantile Store in 1918. Sam Wusich was the grandfather of Creager Wusich. (Creager and DiAnne Wusich.)

Frank Ballesteros earned his bachelor of arts degree from Arizona State University in 1954; the occasion was celebrated by his family members. From left to right are Eulalio, Frank, Angie, youngest sister Jean, Dora, and Gilbert Ballesteros. Frank taught high school at Superior and at Miami. (Eulalio Ballesteros.)

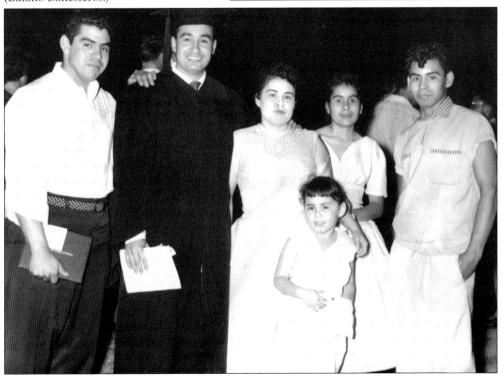

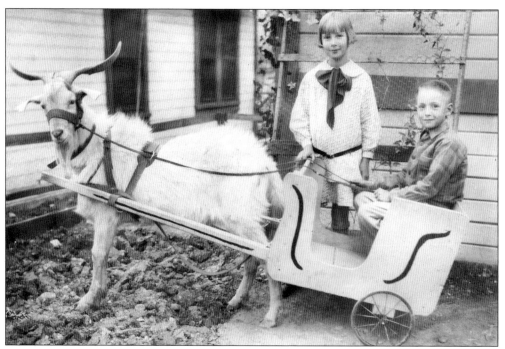

Traveling photographers plied their trade for sales in the neighborhoods of Miami and Globe. In 1928, Wilma and John V. Hays enjoy a make-believe ride in a goat-pulled cart while they pose for a picture at their home, located at 519 High Street. (Bill Bell.)

This YMCA boys group is called the Golden Bears. Shown in about 1945 are, from left to right, (first row) Fred Ordorica, Lindsey Williams, Johnny Ordorica, Porky La Roque, and Virgil Hundley; (second row) Joe Sanchez, unidentified, Perry Laihon, Rudy Garcia, Bobby Olivas, Jerald Trion, and unidentified; (third row) Tom Hunley, Gary Valentine, Joe Edgzein, Keith Drzeohinger, unidentified, Stanley Dorsich, Ralph Guadiana, and an unidentified coach. (Fred Ordorica.)

Andy Devine, the popular movie star who appeared in Western cowboy shows with Gene Autry in the 1940s and 1950s, visited Miami. Pictured in about 1952, he is holding four-year-old Danny Valenzuela on his lap for a photograph. Other children wait in line for a chance to say hello and to have their pictures taken. (Catalina Valenzuela.)

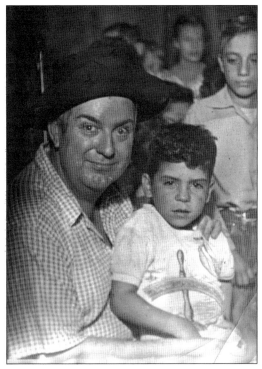

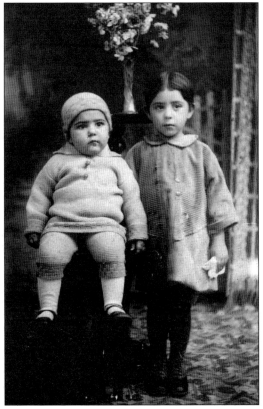

Catalina C. Vega (left), age one, poses with her sister Lorena C. Vega, age five, in Miami around 1927. Fortunato Vega and Antonia C. Vega, parents of the girls, lived on Live Oak Street. (Catalina Valenzuela.)

At the Miami High School multiple-class reunion in 2007, the class of 1951 celebrates with a photograph. From left to right are (first row) unidentified, Anna Lee Price, Joan Nasser, Peggy Rouse Snow, and two unidentified alumnae; (second row) only Roberto Reveles (far right) is identified; (third row) two unidentified alumni, Eli Lazovich, Rudolph Moreno, Jesus Romero, and Mike Santellanes. (Manuel Torrez.)

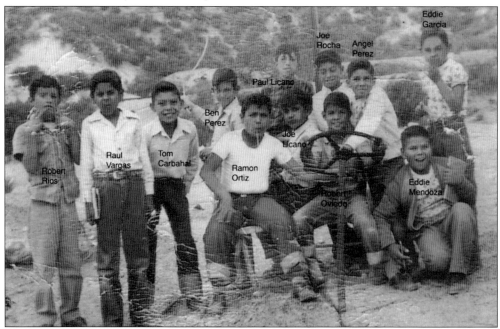

A group of neighborhood boys plays around their homes on Loomis Avenue, also known as Turkey Shoot, in about 1950. From left to right are (first row) Robert Rios, Raul Vargas, Tom Carbajal, Ramon Ortiz, Joe Licano, Robert Oviedo (sitting at the wheel), and Eddie Mendoza; (second row, standing) Ben Perez, Paul Licano, Joe Rocha, Angel Perez, and Eddie Garcia. (Paul Licano.)

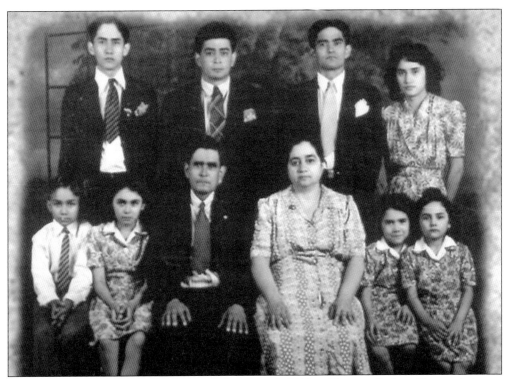

The Trujillo family reunion was celebrated on May 8, 2010, at Kiwanis Park in Tempe, Arizona. From left to right are (first row) Adolph Trujillo, Esther (Trujillo) Alvarado, Refugio Trujillo (father and miner), Agapita Trujillo (mother and homemaker), Josie (Trujillo) Contreras, and Connie (Trujillo) Tapia; (second row, standing) Fernando Trujillo, Salvador Trujillo, Manuel Trujillo, and Mary Trujillo Perez, who worked at Real Market. The Real Market, owned by John Lazovich, began serving the town of Miami the early 1900s. (Trujillo Family.)

Family and friends line up for delicious food, enjoyed outdoors on park tables amid happy conversation. This was the fourth family reunion. Danny Martinez, a family friend, prepares the outdoor "come-and-get-it" lunch. (Santos C. Vega.)

Arnold Trujillo (left) graduated from Miami High School in 1971 and is a professor at Arizona Western College in Yuma. Richard Trujillo (right) graduated from Miami High in 1967 and is retired from teaching and coaching at Tempe High School. The two brothers helped organize the Trujillo family reunion. (Santos C. Vega.)

Friends and family members enjoy the Trujillo family reunion. Standing are, from left to right, Sammy Munoz, who graduated from Miami High School in 1953 and taught school in Tempe for 35 years; Lupe Acosta Siqueiros and her husband, Leo Siqueiros; Sophia Acosta Trujillo, the mother of Arnold and Richard Trujillo; and Mike Santellanes, who graduated from Miami High School in 1951 and was a veteran of the US Navy and active in agriculture in Costa Rica. (Santos C. Vega.)

Pictured at the Trujillo family reunion is the Acosta family. From left to right are (first row) Sophia (Acosta) Trujillo, Theresa (Acosta) Bautista, Carmen Acosta, Lupita (Acosta) Siqueiros, and Michaela (Acosta) Therrell; (second row) Patricio Acosta, Joe Acosta, and Leo Siqueiros. (Santos C. Vega.)

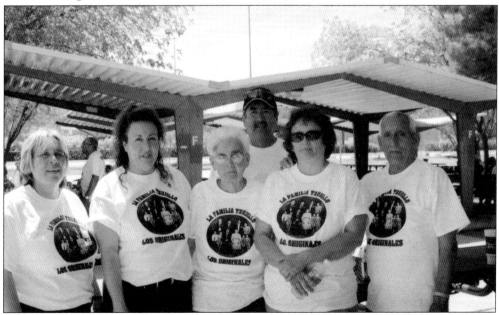

The Trujillo family reunion included several integrated families. The Alvarado family pictured includes Angela (Anthony) Alvarado, Theresa Alvarado, Esther (Trujillo) Alvarado, Loretta (Alvarado) Medina, and Ronald Alvarado. The gentleman standing in back is unidentified. (Santos C. Vega.)

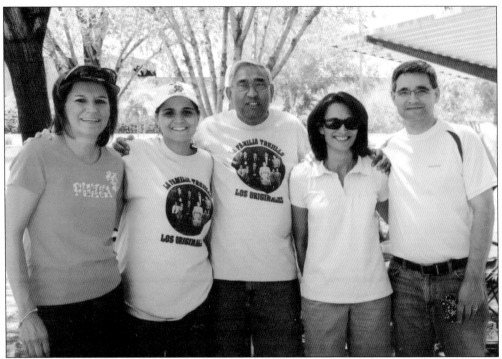

The Adolph Trujillo family includes, from left to right, Christie Hein Trujillo, Nancy Cable Trujillo, Adolph Trujillo, Marla Dorman Trujillo, and John Trujillo. (Santos C. Vega.)

The Arnold Trujillo family enjoys the Trujillo family reunion. Standing from left to right are sister-in-law Martha Bejarano, Arnold Trujillo, wife Margie Trujillo, and daughter Andrea Trujillo. (Santos C. Vega.)

Four

COMMUNITY AT WORK

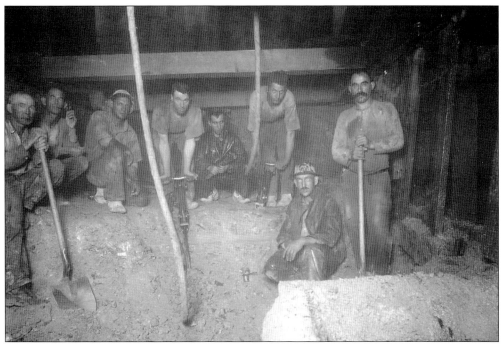

Miami Copper Mine employees are shown working underground on November 20, 1917. Miners used picks and shovels to carve out tunnels and dig ore. As miners dig out tunnels, they reinforce the sides and ceiling with heavy timber and boards. Hoses bring in fresh air. Miners filled an underground railcar with the dirt and rocks. When the author worked 1,700 feet underground in 1958, at the San Manuel Copper Mine, the rail train ran the oar dug out from chutes, and fresh air flowed freely through the tunnels. Later, the copper mines found it more profitable and easier to do open-pit mining. (John E. Stearns.)

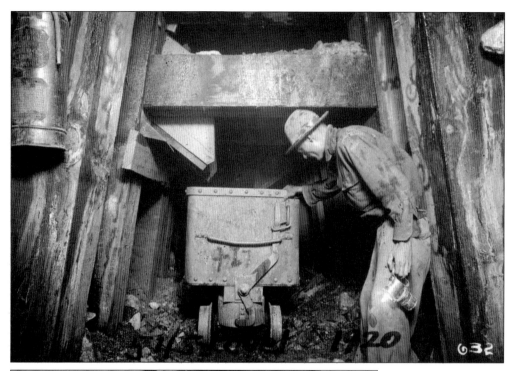

Shown in 1920 are a miner and a mine ore car used for hauling ore out of the 545 level. A fire extinguisher appears to the left. (John E. Stearns.)

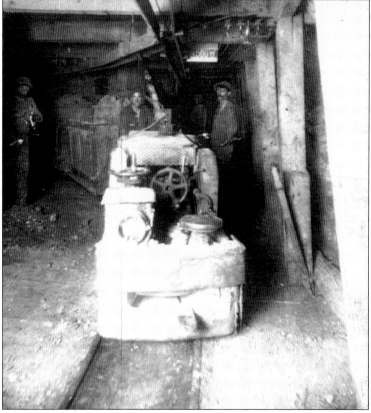

Taken on November 20, 1917, this photograph shows another view of underground mining. An engine is hauling ore out of the mine in ore cars. (John E. Stearns.)

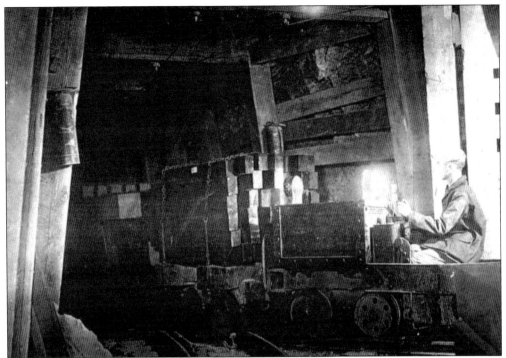

Supply train No. 1147, shown at the 620-foot level, delivers heavy crossties and other supplies for miners working underground in shaft No. 5 in 1917–1920. (John E. Stearns.)

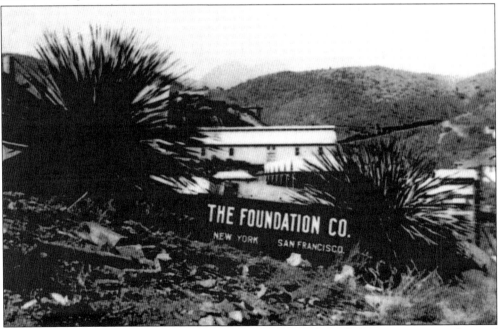

The establishment of copper mining companies in Miami depended on investments of capital from various cities in the United States as well as immigrant labor from 20 or more countries around the world. This picture shows the Foundation Company, of New York and San Francisco, creating copper roots in Miami. (John E. Stearns.)

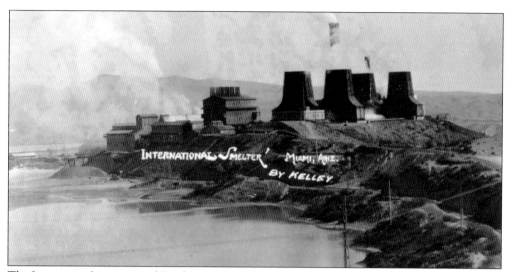

The Inspiration International Smelter received the concentrated ore to smelt in furnaces. Smelter workers shoveled out the mud-like ore waste (known as wet muck) from conveyor belts through large pipes to remove it from the smelter. Because of the shortage of men during World War II, the mine hired women. Lucy Lobato was one of the women employed at the Inspiration Smelter. (Photograph by Kelley's Studio, courtesy of Bill Bell.)

Mine workers were assigned to the smelter to operate train engines to haul copper ore. Pedro Sendejas (right) is pictured with an unidentified worker in 1928. (Mary Sendejas.)

Manuel Huerta, a well-known athlete at Miami High School, served in the US Army after graduation in 1950; when he returned home, he needed a job. A mining program funded his training at a welding school in Phoenix. He became a welder and obtained employment in the truck welding shop at Miami Pinto Valley Copper Company. (Manuel Huerta.)

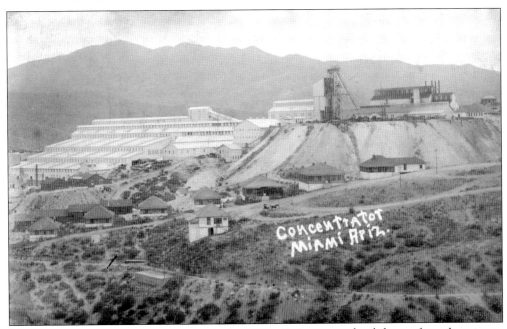

The copper mine concentrator appears in the 1940s. Train ore cars haul the ore from the mine to the concentrator where the copper ore was separated from the waste products, known as tailings, and hauled to the smelter. (Virginia G. Herrera.)

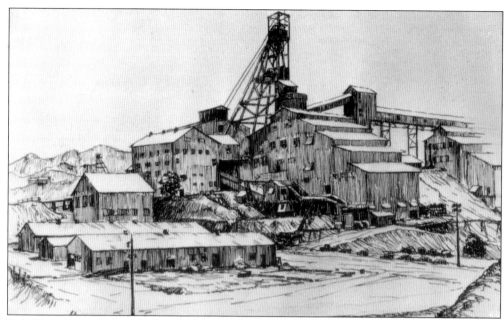

Bob Huggins painted a black-and-white rendition of the Inspiration Copper Rod Plant based on an image he had Norman's Photography in Globe, Arizona, take on April 30, 1968. (Bob Huggins.)

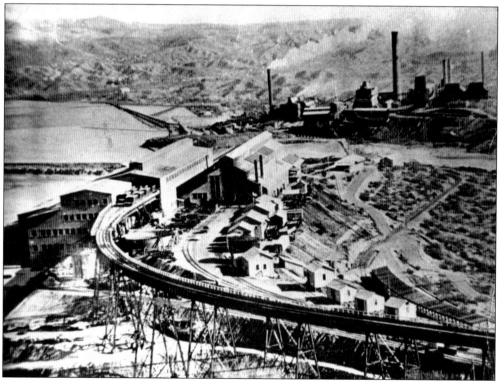

This 1930 image shows Inspiration Ball Mill. In the late 1940s to early 1950s, railroad ore cars hauled the ore to the Ball Mill, where it was crushed. (Bob Huggins.)

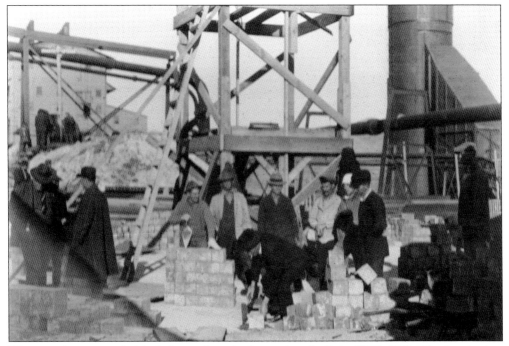

The round structure behind the workers is the smelter, built in 1909–1910. The Inspiration Consolidated Copper Company Smelter received ore from the Miami Copper Company and other mines. (Bob Huggins.)

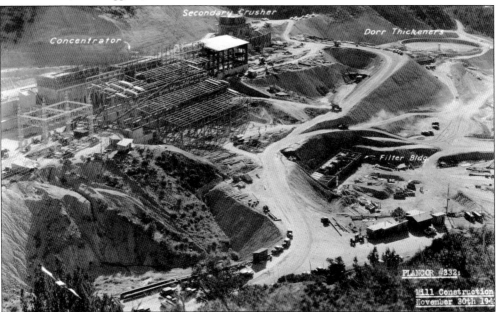

This photograph of the mill construction in 1942 shows the progress of various building sites integral to the process of obtaining and working with copper ore. The ore goes from the mine to the crusher. The concentrator takes the crushed and ground-up ore and isolates the copper. The smelter melts and forms the crushed copper into copper bars, shipped to manufacturers to make wire, cables, and other copper products. (Virginia G. Herrera.)

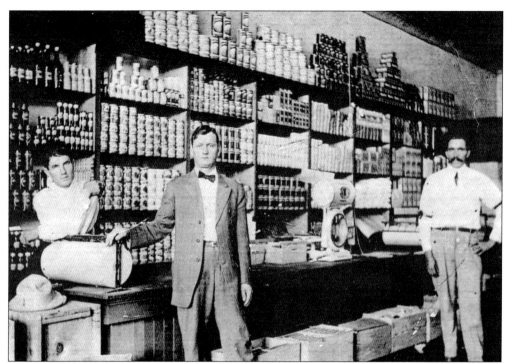

The Mercantile Store, a family-owned business, operated in the early years of Miami, around 1918. Proprietor Sam Wusich also owned the White House Saloon. (Creager and DiAnne Wusich.)

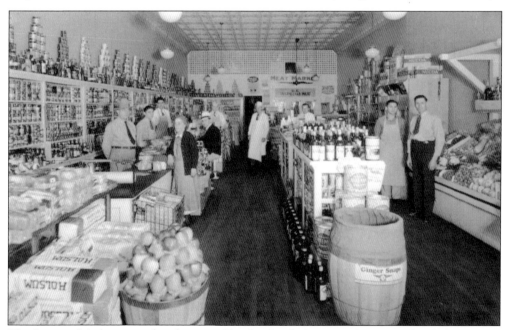

The Sanitary Market, owned and operated by the Greek American Economy family for years, is shown in 1938. There, Miami residents could find the finest meats, produce, baked goods, liquors, and sundries. Several resident families such as the Acostas, Becerrils, De Andas, Fernandezes, Sendejases, Wusiches, and Lazoviches, among others, owned and operated grocery stores. (Joe Sotelo.)

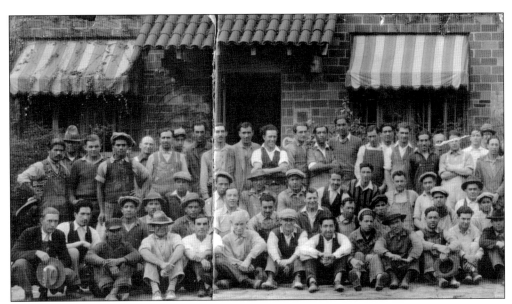

Old Dominion Mine workers pose for a picture in about 1920 in Globe, Arizona. According to the *Historic Resource Survey*, the Old Dominion Mining Company built the first reduction works and smelter west of Miami, at Bloody Tanks Wash, in 1882. The high cost of transportation made it difficult for the Old Dominion to continue production. Numerous miners worked in the mines in Miami but lived in Globe. (Raquel R. Gutierrez.)

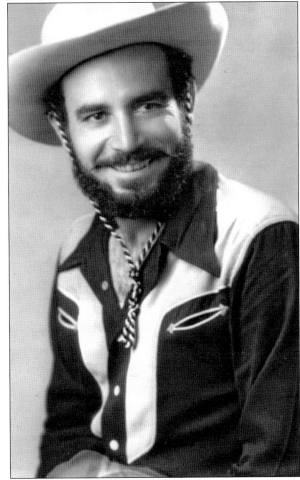

Robert Barcon wears his Western outfit and sports a beard for Miami's 1948 fourth annual Boomtown Spree beard contest. The different contest divisions were the longest, the most unique, the bushiest, and the most colorful. Robert Barcon may or may not have won the beard contest. He is better remembered for his union-organizing activities with Mine-Mill Local 586, achieving improved safe work conditions and equality in pay. (Elisa Muñoz.)

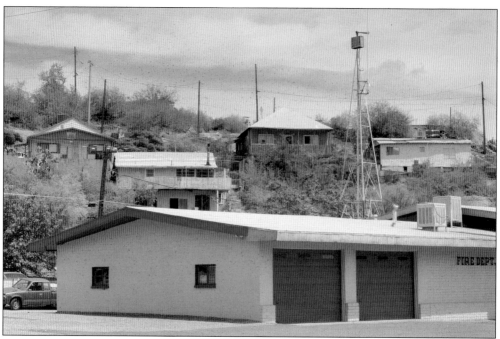
The Miami Fire Department changed locations through the years. It now operates from the building seen here on Sullivan Street, at the corner of Gibson and Davis Canyon. (Santos C. Vega.)

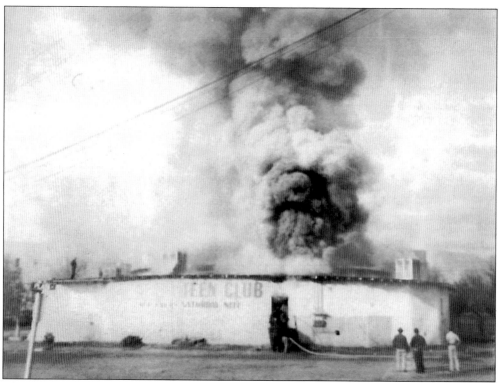
This picture shows the Bullion Plaza Dance Hall on fire in 1967. (John E. Stearns.)

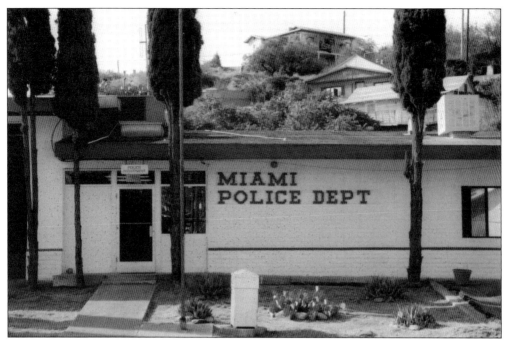

The Miami Police Department also changed locations through the years. It is shown at its current home on Sullivan Street, on the corner of Davis Canyon and Gibson Street. (Santos C. Vega.)

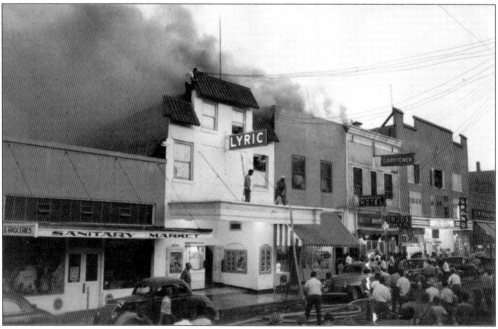

The Lyric Theater caught fire in the late 1940s. Since the 1930s, the Lyric entertained Spanish-speaking audiences with movies from Mexico starring such Mexican stars as singers Jorge Negrete and Pedro Infante, actress Maria Felix, and comedian Mario Moreno "Cantinflas," who became popular in the United States in the 1950s when he starred in *Around the World in Eighty Days*. (Virginia G. Herrera.)

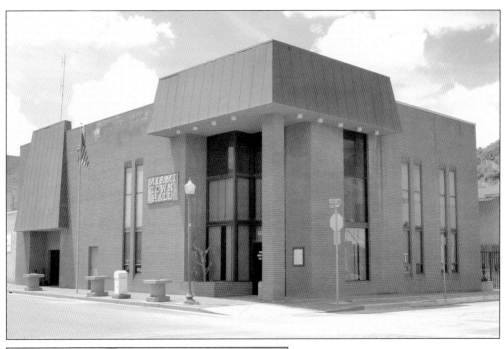

The Miami Town Hall occupies the same location it has since the 1940s, but it was recently remodeled. (Santos C. Vega.)

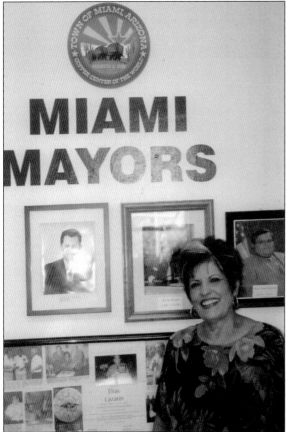

The Miami Town Council elected Rosemary Blair Castaneda the mayor of Miami, Arizona, in 2010. She is the second woman elected as mayor in the town's political history. Katie Weimer, elected in 1976, was the first female mayor. (Santos C. Vega.)

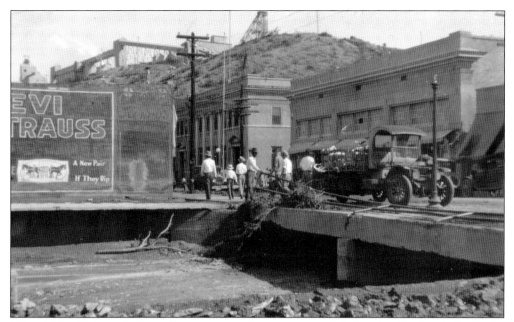

Miami's Live Oak and Sullivan Streets were built on a large creek bed and suffered periodic floods. Several measures undertaken to curb the floods, including a cement wall containing the wash, produced no solution. This picture shows a flooded street in 1917–1918, with workers attending to the flood damage in a 1917–1918 Ford truck. (John E. Stearns.)

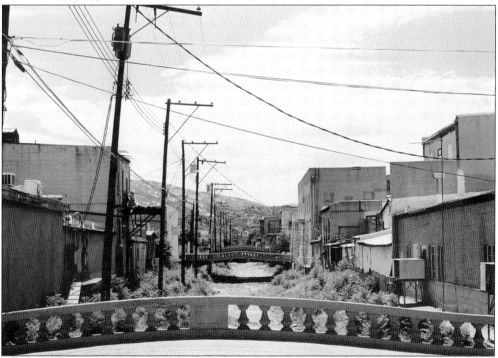

Several concrete bridges connect Miami's two main streets—Live Oak on the south side and Sullivan on the north side—which are separated by the central town wash, cement-walled to control floodwater rushing from west in the Pinal Mountains to the east. (Santos C. Vega.)

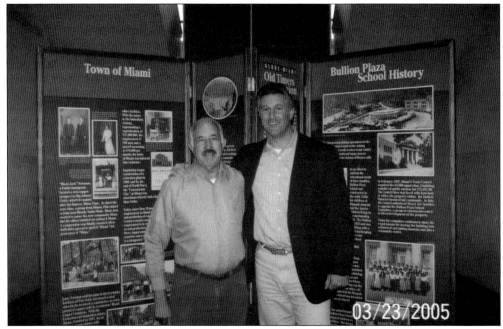

Paul C. Licano (left) stands with Rick Renzi, the congressman from District 1, inside the Bullion Plaza Cultural Center & Museum, on March 23, 2005. Paul, an active member of the museum's board of directors, served as the Miami Town Council's vice-mayor. (Paul C. Licano.)

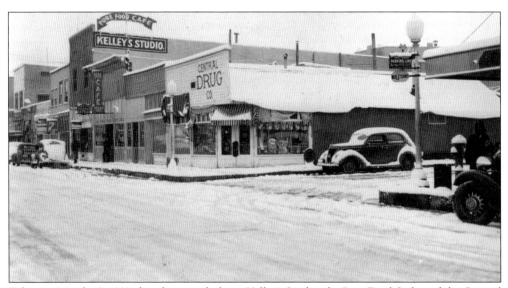

Taken on March 19, 1939, this photograph shows Kelley's Studio, the Pure Food Café, and the Central Drug Company along the Sullivan Street business district in Miami, blanketed in snow. Virginia (Guadiana) Herrera worked for Central Drug Company for 35 years. (Virginia G. Herrera.)

In 1931, the Miami Women's Club transformed its clubhouse into the Miami Public Library. Mine timbers became library shelves, and old counters became desks. Miami town doctors contributed new lights, and today, the globes are memorials. Workers installed showcases from abandoned stores, like Kelley's Studio. This photograph of the Miami Memorial Library was taken on September 17, 2010. (Santos C. Vega.)

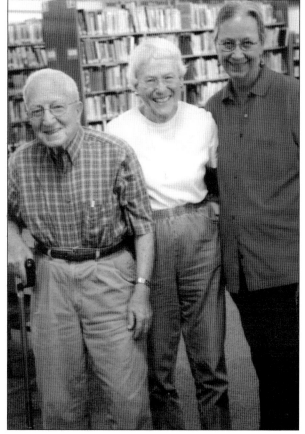

Inside the Miami Memorial Library, Nick Rayes (left) and spouse Betty B. Rayes (center) were assisted by library manager Delvan Hayward, who started working at the library in 2005. She also serves as a founding member of the Bullion Plaza Cultural Center & Museum. (Santos C. Vega.)

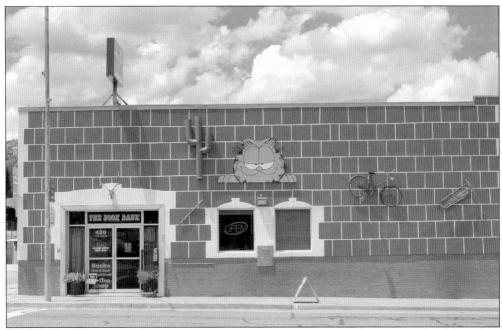

The Book Bank occupies the former Valley National Bank building. The original building, constructed in 1918, served as a town bank, and a health clinic occupied the upper level for years. (Santos C. Vega.)

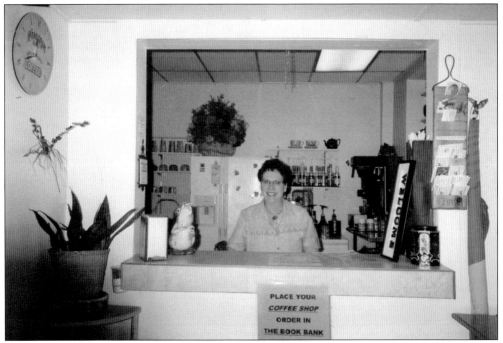

Marlene Tiede is seated at the Book Bank bookstore refreshment area. Marlene is the proprietor of the business, which she started in March 2002. She markets used books of nearly every genre. The store also carries new books by local writers. Tiede enjoys being able to support local authors in their endeavors. (Santos C. Vega.)

Mexican restaurants—originally known as La Paloma Café (left) and El Rey (right)— have always been located on Sullivan Street. A Mr. Mora owned La Paloma from the late 1920s to 1940s. Afterward, it changed hands several times. However, it kept the La Paloma name until recently, changing to Chelo's Casa Reynosa. Both places continue to serve delicious meals. (Santos C. Vega.)

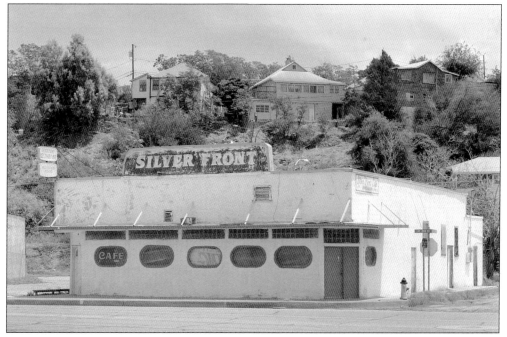

After many years, the Silver Front Bar and Restaurant, located on Live Oak Street, continues to serve residents. For a time, Henry Benetez and Babe Encinas operated the bar, and Angela Reveles ran the restaurant. Others managed the bar or the restaurant at different times. (Bill Bell.)

A popular mom-and-pop store known as Don Pablitos sold meats, produce, and canned goods. The store, operated since the 1930s, had changed locations through the years, but it remained sought-after by children for its raspadas, which were shaved ice sweetened by bright red, purple, green, or yellow fruit syrups and served in paper cone-shaped cups. DeAnda's Grocery on Mexican Canyon was Don Pablito's last location. (Santos C. Vega.)

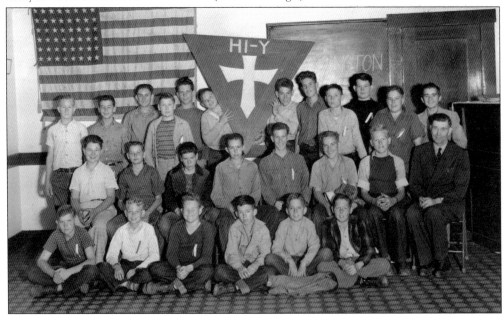

Shown in 1944, this group of boys participated in the YMCA's Hi-Y program. From left to right are (first row) unidentified, Virgil Valentine, Henry Andrews, John Conniff, and two unidentified boys; (second row) Edward Maxwell, Bobby Davis, unidentified, John Peterson, Bill Bodine, Eugene Davis, unidentified, and unidentified group counselor; (third row) the only boy identified is Larry Philip (third from left); all boys in the fourth row are unidentified. (Betty Beneteau Rayes.)

Mary Sendejas graduated from Miami High School in 1951. She then earned her registered nurse (RN) degree at St. Mary's School of Nursing in Tucson, in 1951–1956. Sendejas spent a lifetime nursing in various places, including Gila County Hospital, Miami Inspiration Clinic, St. Joseph's and Good Samaritan Hospitals in Phoenix, and at Disneyland. She has owned her own home health care business in California for 30 years. (Mary Sendejas.)

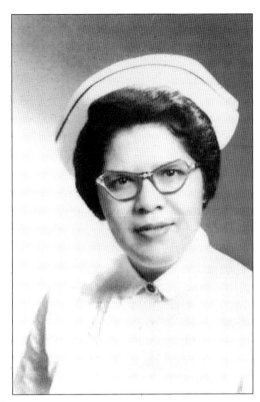

Catalina Valenzuela worked in the Hughes Aircraft factory in Tucson, Arizona, in 1942, helping to build B-24 bombers for the World War II effort. (Catalina Valenzuela.)

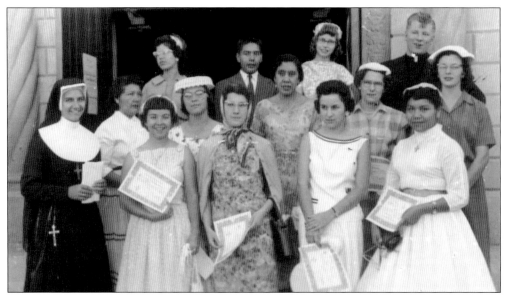

After finishing their religious training program, Miami faithful received certificates of completion at St. Augustine Cathedral, built in 1776, in Tucson. Taken in 1958, the picture shows, from left to right, (first row) Sister Dolorine, MHSH, Mary Jane Priniski, Patricia Inbody, Virginia Coppa, and unidentified; (second row) two unidentified ladies, Mary Ortega, Betty Beneteau, and Karen Van De Beueken; (third row) unidentified, David Leyva, unidentified, and Fr. John Martin. (Betty Beneteau Rayes.)

Friends at the Miami Old-Timers Reunion gather for a picture in about 1972. They were born in the mid-1920s, and most had served in World War II. From left to right are (first row) Manuel Campos, two unidentified old-timers, and Jimmy Casillas; (second row) Arthur Mariscal, unidentified, Felix Bracamonte, Ray Arrona, Fernando Romero, unidentified, and Arnold Rojas. (Lucy Rojas.)

In 1932, the Miami Methodist Church on Adonis Avenue, moved its membership to the Claypool Methodist Church and turned over its building to the Mexican Methodists. This photograph shows the Mexican Methodist Church as it looked in the 1950s. The building is no longer there, and it is unknown when the church held its last services or when its building was demolished. (Sammy Obregon.)

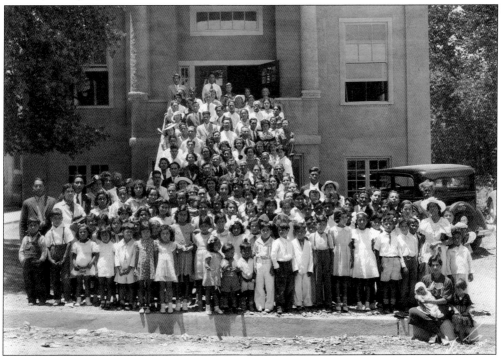

Pictured in 1937, the Mexican Methodist Church on Adonis Avenue served Mexican Methodist and Presbyterian congregations from Miami and Phoenix. (Sammy Obregon.)

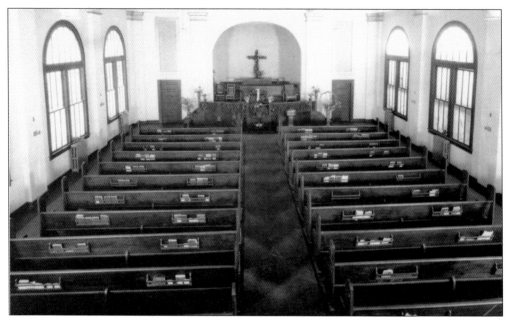

Presbyterian missionaries organized Miami Presbyterian Church, the first church established in town, in October 1910. This 1920 picture shows the inside of the building, located on 305 Live Oak Street. Prior to 1920, the congregation occupied a small frame building constructed in 1911 located across the street. In 1986, the Spanish- and English-speaking congregations united as Divine Grace Presbyterian Church. (Charles and Peggy Snow.)

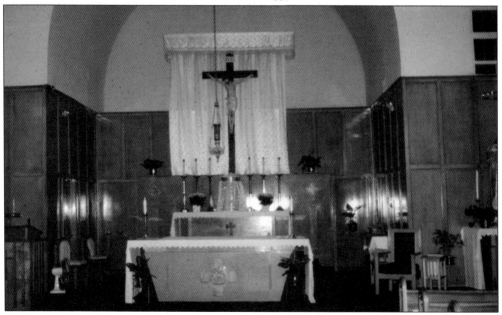

Our Lady of the Blessed Sacrament Church, located at 914 Sullivan Street, was constructed in 1915. Prior to this, the Catholic faithful celebrated Holy Mass at Miami's first Catholic church, Sacred Heart, situated in a wood-frame house built on top of a hill north of Sullivan Street and adjacent to (east of) Davis Canyon. The hill yet retains the name *Church Hill*, even after the church became a residence. (Santos C. Vega.)

Buena Vista School, built in 1924 in the Buena Vista Terrace addition, served children from the several surrounding canyon and hill neighborhoods, including Loomis Avenue, popularly known as Turkey Shoot, in the east part of town. It eventually closed and became a private residence. (Santos C. Vega.)

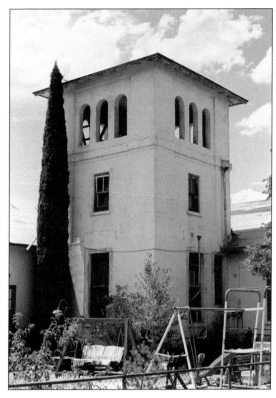

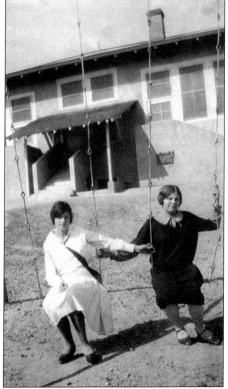

Central School, located on the hill southeast of Red Street Canyon, was the first school building in Miami. It provided a flat area for recess and had swings for recreation. Friends Katie Pavlich Duncan (left) and Mary Besich Halford enjoy the swings during what seems like a nice, sunny day around two o'clock in the afternoon, based on their shadows on the ground. Central School was built in 1911 and was demolished years later. (Mary Pavlich Roby.)

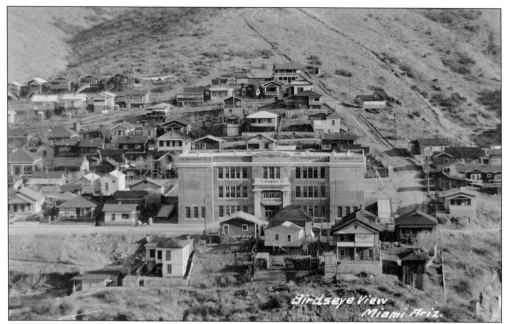

A bird's-eye view of the town shows how steep the mountain roads are. The houses, built mostly of wood, are crowded among each other with little space between them and sit alongside winding streets and steep roads atop hills. The large building in the center of the picture is the Inspiration Addition School. Built in 1910, it is still in use today. (Bill Bell.)

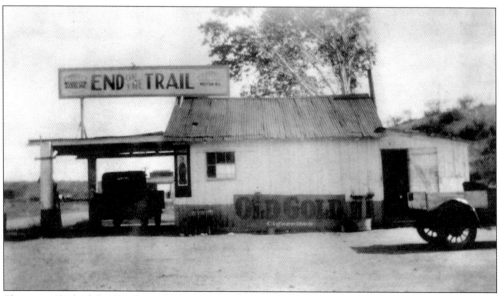

Shown is End of the Trail gasoline station, where drivers could purchase gas and motor oil for their cars and buy groceries and Old Gold cigarettes. Around the late 1920s, the station, located in Claypool, was probably near the north turn on Wheat Fields Road, before it becomes Apache Trail and goes past Roosevelt Dam and on to the Phoenix area. (Bill Bell.)

Five

MILITARY SERVICE

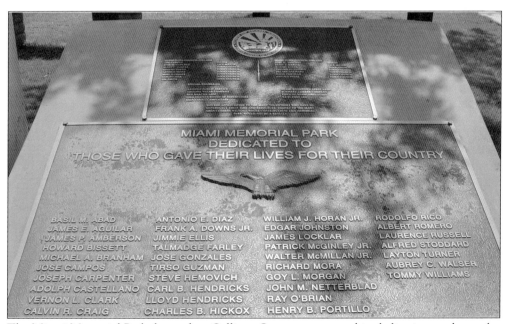

The Miami Memorial Park, located on Sullivan Street, was created in dedication to those who gave their lives for their country. It graces the town, reminding all to remember the contributions made by US servicemen and women. (Santos C. Vega.)

Matilde (Gradillas) Herrera, born March 14, 1897, raised eight sons, seven of whom served in all branches of the US armed forces from World War II to the Korean War. The US government honored Matilde with a US Citizenship Award. *Silver Belt*, the Miami newspaper, reported on the story. (Virginia G. Herrera.)

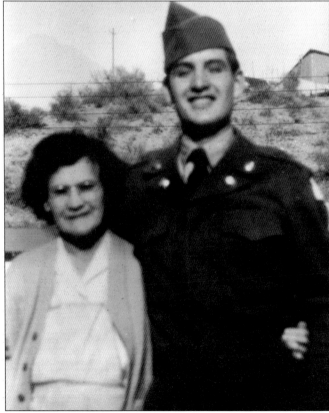

Matilde G. Herrera and her son Ernest Herrera are pictured in front of their home in Davis Canyon. Ernest served during the Korean War in 1951. He participated with other troops when the government tested bombs in Nevada. Ernest later developed leukemia and died. (Virginia G. Herrera.)

Pfc. Vicente Rincon Valenzuela served during World War II with the Fifth Army, 81st Infantry Division, 323rd Infantry Regiment from June 12, 1942, to December 15, 1945. He participated in action in the Asiatic-Pacific theater, involved in battles and campaigns in the Southern Philippines and Western Pacific. Valenzuela received an honorable discharge on January 10, 1946, at Fort MacArthur, California. (Catalina Valenzuela.)

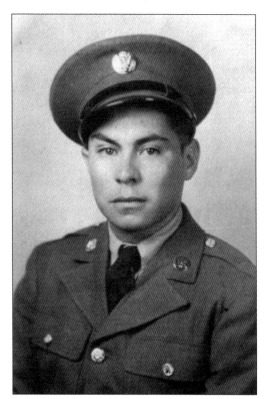

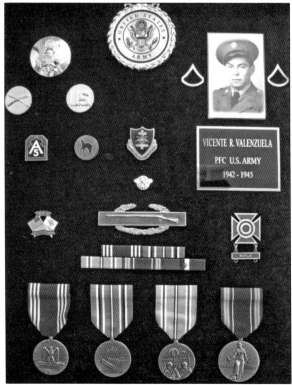

Pfc. Vicente R. Valenzuela, involved in battles and campaigns in the Southern Philippines and Western Pacific, earned the Army Good Conduct Medal, American Campaign Medal, Asiatic-Pacific Medal, World War II Victory Medal, Philippine Liberation Ribbon with one bronze star, and the Ruptured Duck Lapel Pin for faithful service. He also earned the Combat Infantry Badge and the Sharpshooter Badge with rifle bar. (Catalina Valenzuela.)

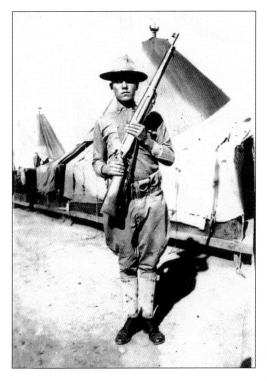

Thomas G. Carbajal volunteered for military service at the beginning of World War I in 1917. After infantry training, he fought in France with his infantry combat unit. Thomas encountered the threat of mustard gas. Born in Morenci, Arizona, in 1898, he moved with his parents, Jose and Manuela Carbajal, to Miami when in his early teens. After the war, Thomas worked as a furniture refinisher, repairing crank phonographs and radios. (Arthur C. Hernandez.)

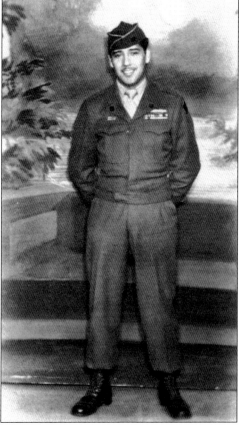

Arthur C. Hernandez was drafted into the US Army, assigned to the 7th Infantry Division in the Pacific theater during World War II, and participated in the battle of Okinawa. Twice wounded in combat, he received a Purple Heart Medal with one Oak Leaf Cluster, two Bronze Star Medals, the Combat Infantry Badge, and a Presidential Citation signed by Pres. Harry S. Truman. (Arthur C. Hernandez.)

Sylvia J. Almeyda, a 1935 Miami High School graduate, served in the US Nurse Cadet Corps in 1942–1945, during World War II. She studied at St. Mary's Hospital in Tucson to prepare for duty, but she did not go overseas because the war ended. Sylvia worked at St. Mary's Hospital and went on to serve as a nurse in California for 45 years. She married Alfred Almeyda, a World War II veteran. They returned to Miami in 1986. (Sylvia J. Almeyda.)

Rodolfo Barcon served in 1941–1946, during World War II, with Company L, 17th Infantry Regiment, 7th Division in the Asiatic Pacific theater of operations. He fought in the Aleutian Islands where he received a citation for bravery. Rodolfo earned three Bronze Star Medals, the American Defense Service Medal, and the Philippine Liberation Medal with two Bronze Stars. Born in Miami on December 20, 1919, he died in Los Angeles on November 9, 1962. (Elisa Muñoz.)

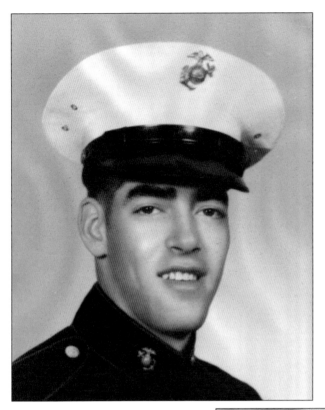

Fred Ordorica, born in 1935, graduated from Miami High School in 1953 and joined the US Marines, during the Korean War. He completed his basic training in San Diego. Fred served in Balboa Hospital in South Dakota. After his discharge, he worked for the Miami Copper Company and later for Magma Copper Company, from where he retired. (Fred Ordorica.)

In 1943, during World War II, Pvt. Joe Sotelo joined the US Army at age 24. He served with the First Army, 104th Timberwolf Division, 413th Infantry Regiment in the European theater. He received the Purple Heart in Cologne. After the war, he actively participated in Miami town activities, including serving as a director of the Miami Community Builders, which sponsored Miami's fourth annual Boomtown Spree festival in May 1948. (Joe Sotelo.)

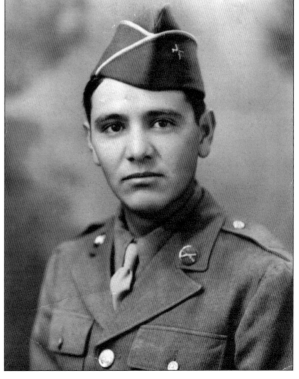

Gilbert Canizales served with the US Army in Germany in 1953, during the Korean War. (Raquel R. Gutierrez.)

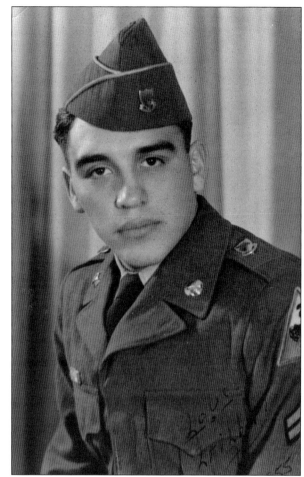

Pfc. Vicente Valenzuela served in the US Army during World War II. He is shown taking part in a funeral honor guard as part of the three-soldier color guard; Valenzuela is to the left of the flag carrier. (Catalina Valenzuela.)

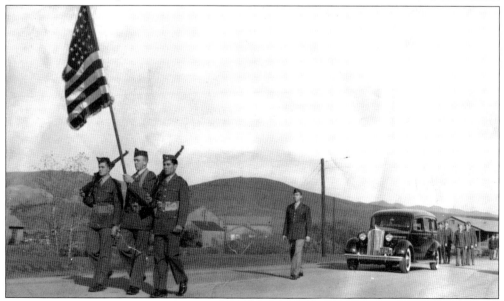

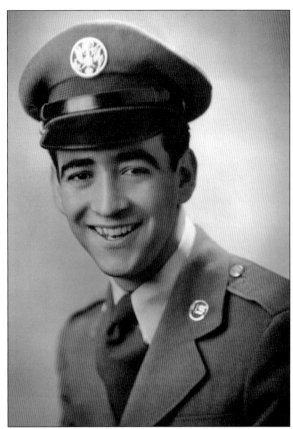

When a young student at Miami High School, Manuel F. Sepulveda, enlisted in the US Air Force in August 1952 and continued his career for 20 years, serving in the US Air Force, the Air Force Reserve, and the Arizona Air National Guard. He earned the rank of senior master sergeant (E-8). In 1970, while at Norton Air Force Base in California, he won the Air Force Reserve's National Outstanding Recruiter Award. (Manuel F. Sepulveda.)

S.M.Sgt. Manuel F. Sepulveda had three sons who also had military careers. From left to right are Monte Sepulveda (master sergeant, E-9, US Air Force), Manuel F. Sepulveda (senior master sergeant, E-8, US Air Force), Marcos Sepulveda (senior master sergeant, E-8, US Air Force), and Martin Sepulveda (lieutenant colonel, commander). Monte served for 20 years and is retired. Martin is active and plans to serve 30 years. Marcos has served 13 years and is still active. (Manuel F. Sepulveda.)

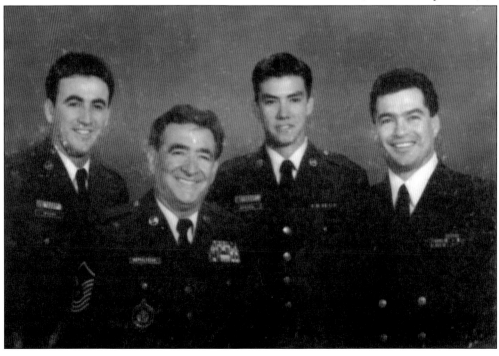

Bertha Munoz and George Sanchez got married during George's tour of duty in the Army, in 1951 during the Korean War. Both attended Miami schools. George later completed his degree in optometry, and he continues to provide eye care in both Miami and Tempe, Arizona. They reside in Tempe. (Bertha M. Sanchez.)

Sam Obregon enlisted in the US Army and served from September 1952 to September 1954. Pictured from left to right are William Moseley (Illinois), unidentified, Don Roberts (West Virginia), Sam Obregon (Miami, Arizona), and unidentified. The soldiers had completed their basic training at the 5th Armored Division, Camp Chaffee, Arkansas. They celebrated their first weekend pass with dinner at a restaurant in Fort Smith, Arkansas, in 1952. (Sam Obregon.)

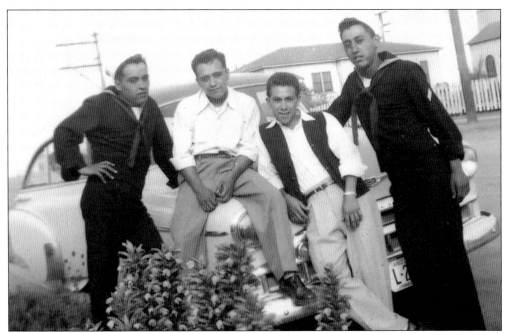

Many young men and women from Miami have served their country in the various wars. This group picture was taken in San Diego, California, in 1950, during the Korean War. From left to right are Juan Carillo Hernandez, Eberto Hernandez (Juan's twin brother), Dave Williams, and Manuel Trujillo. Juan and Manuel had joined the US Navy, as denoted by their uniforms. (Juan Hernandez.)

Cpl. Manuel (Delgadillo) Huerta served in the US Army 24th Infantry. He enlisted after his Miami High School graduation in 1950 and was stationed in Korea in 1951 and in Japan in 1952. (Manuel Huerta.)

By the time World War II ended in 1945, many sons and daughters of Miami residents had served in the armed forces. From left to right are Robert "Bob" Olguin (Navy), Alfonso "Poncho" Echeveste (Army), and Elvira Echeveste (Navy WAVES). Alfonso and Elvira are brother and sister; Bob is their uncle. (Sam Echeveste.)

Sfc. Sam Echeveste served in the US Army in 1951–1954. He was a platoon sergeant in the 3rd Infantry Division during the Korean War. After discharge, he earned a bachelor of arts and a masters degree and taught high school in Indio, California. He joined the Military Department of Defense Overseas Corp and served as a high school teacher overseas, where he met his wife, Berta, in Austria. (Sam Echeveste.)

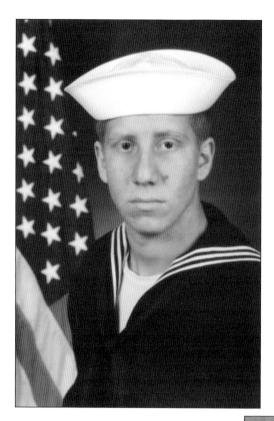

Chris Magaña is shown on November 19, 1986, while in basic training at San Diego, California. He served in the US Navy. Chris was born and raised in Miami, and he attended local schools. (Catalina Valenzuela.)

Danny Valenzuela served in the US Army in 1968–1970, during the Vietnam War. He was stationed in Germany until his discharge. Before his service, he attended Eastern Arizona College and Northern Arizona University and had a college deferment, but in June 1967, the Army drafted him. Upon his discharge in 1970, he enrolled full-time at Arizona State University and in December 1974, received his bachelor of science degree in management. (Catalina Valenzuela.)

Six

ACTIVITIES, EDUCATION, AND SPORTS

The Alianza Hispano Americana Logia (Lodge) No. 58 holds one of its meetings on January 25, 1948, at the meeting hall of the Blessed Sacrament Parish in Miami, Arizona. Ramona Padilla Echeveste served the fraternal organization as secretary. She is sitting at the table on the far right, in the foreground of the picture. The Alianza Hispano Americana, founded in Tucson in 1895, spread throughout towns and cities in the Southwest. (Sam Echeveste.)

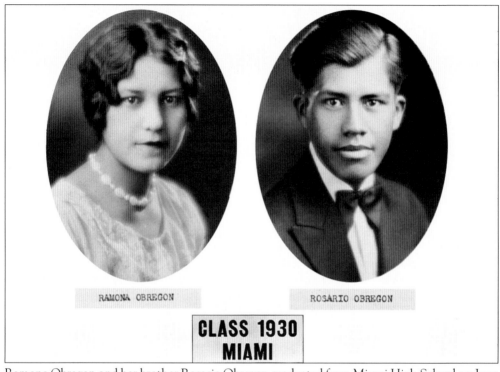

Ramona Obregon and her brother Rosario Obregon graduated from Miami High School on June 4, 1930. (Sammy Obregon.)

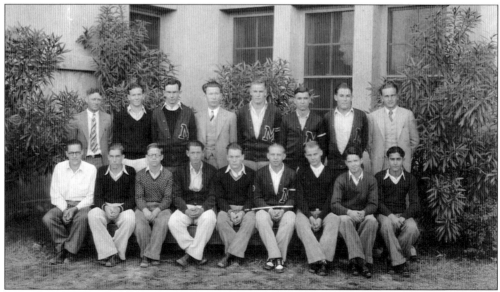

A picture of the Miami High School Letterman's Club of 1933 includes Dale Beedle (standing, far left) and Kenneth Beedle (standing, second from left). The others are unknown. Dale Beedle may very well have been the greatest athlete in football to come out of Miami High School; he played with Stanford in the 1934 Rose Bowl game. (Betty Beneteau Rayes.)

Bullion Plaza School district track champions competed in the 1935–1936 Luke Greenway Arizona State Championship Track Meet. Pictured are, from left to right, (first row) Manuel Lopez, J. Lopez, ? Gaona, Dan Romero, unidentified, Raul Romero, and Salvador Portillo; (second row) Felix Bracamonte, unidentified, ? Lopez, "Che" Diaz, ? Gutierrez, ? Flavio, ? Castellano, and Joe Sotelo; (third row) Frank Renteria, Ramon Fierro, Fernando Romero, Roberto Trujillo, unidentified, and Reyes Herrera; (fourth row) Richard Mora and coach Nick Ragus. Unable to purchase track shoes, most of the boys ran barefoot, but they won the meet. Judges awarded them second place. Bullion officials contested, and the team ended up wining first place. (Joe Sotelo.)

The Lower Miami George Washington Elementary School first-grade class of 1938–1939 consists of, from left to right, (first row) George Perez, Julian Avalos, Concepcion Perez, Gloria Moreno, Hermelinda Tresigo, Valentine Garcia, Mercy Sendejas, and John Encizo; (second row) George Burgess, Arnold Lopez, Lupe Gaona, Eddie Padilla, Gilbert Arciniega, Amalia Garcia, Emilia Hernandez, and Candido Rivera; (third row) Mary Sendejas, Junior Avila, Ernesto Duran, Celia Moreno, Samuel Echeveste, Augustine Gonzales, Lydia Ramos, and Consuelo Sendejas; (fourth row) Lupe Flores, Lucy Magdaleno, Petra Carbajal, Pedro Carbajal, Martha Gonzales, and Marie De Luna. (Samuel Echeveste.)

Pictured at the Inspiration Addition School Eighth-Grade Graduation on May 27, 1948, are, from left to right, (first row) Helen Sandoval, five unidentified students, Louise ?, unidentified, Patsy Slack, Alice Cortez, two unidentified students, Cindy Dougherty, and Raquel Ruiz; (second row) principal O.B. Joy, four unidentified students, George Henderson, Andy Rumic, three unidentified students, Mary Lou Fernandez, unidentified, Leon Joy, and two unidentified students; (third row) Danny Kincaid, two unidentified students, Glenn ?, unidentified, Charlie Moore, two unidentified students, Larry Lubich, three unidentified students, and teacher Bess Blair. (Raquel R. Gutierrez.)

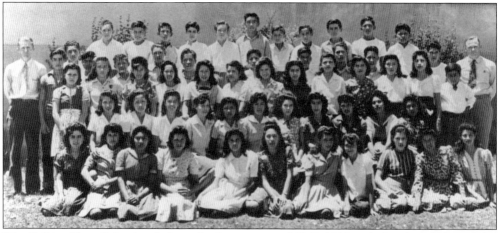

The Bullion Plaza School eighth-grade class picture of 1941–1942 includes, from left to right, (first row) Catalina C. Vega, Esperanza Sanchez, Eufemia Herrera, Enedina Reyes, Cruz Espinoza, Manuela Soto, Annie Platt, Clara Flores, Catalina Angulo, Ernestina Montez, and Olivia Obedia Feliz; (second row) Refugio Romero, Ermelinda Lopez, Belia Reyna, Margaret Campa, Candelaria Ayala, Mary Lopez, Elisa Olivas, Elena Santellanes, Juanita Trujillo, Elisa Escobedo, and Agripina Hernandez; (third row) Lita de la Torre, Irene Armendarez, Socorro Romero, Socorro Gonzales, Rosa Gonzales, Elvira Jimenez, Christina Bocardo, Belia Seras, Mary Rocha, Romelia Rubalcava, Mary Arellano, Grace Canizales, and Elias Gonzales; (fourth row) teacher Mr. Soderman , Alex Chavez, Marcelino Herrera, Henry Portillo, Adolfo Bojorquez, Alfred Dominguez, Lorenzo Contreras, Frank Gonzales, Carlos Mendiola, Ignacio Flores, Raul Gutierrez, Robert Laguna, and principal Mr. Johnson; (fifth row) Joe Bojorquez, Romiro Oquita, Ernest (Remos) Jauregui, Daniel Macias, Gilbert Madrid, Miguel Rivera, Vicente Sarmiento, Jesus Herrera, Raul Jacott, Manuel Acevedo, and Edward Ramos. (Elisa Muñoz.)

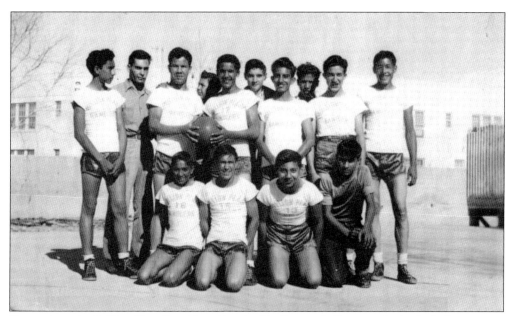

Pictured are the Bullion Plaza Ramblers. Coached by Fernando Romero, the basketball team won the district in 1947. From left to right are (first row) Adolfo Trujillo, Richard Martinez, Richard Vargas, and Elias Delgadillo (Huerta); (second row) Frank Bautista, coach Fernando Romero, Joe Gutierrez, Fred Lugo, Lupe Acevedo, Ernest Herrera, Frank Barraza, Theodore Barajas, Manuel Torrez, and Rudy Moreno. During high school, many of the same boys won conference, district, and state championships in 1950–1951. (Manuel Torrez.)

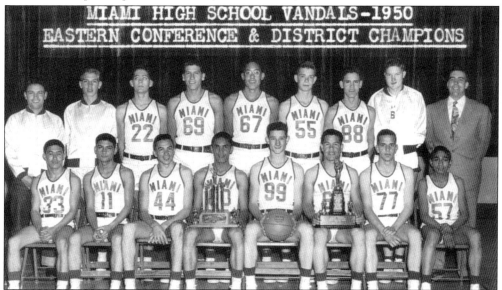

Miami High School basketball teams won championships in 1950 and 1951. In 1950, the team won district and Eastern Conference titles. Pictured from left to right are (first row) Richard Martinez, Elias Huerta, Jesus Romero, Lupe Acevedo, Eli Lazovich, Joe Gutierrez, Serafin Arduengo, and Adolph Trujillo; (second row) manager Manuel Huerta, Harold McNair, James F. Ticknor, Alfred Lobato, Rudolph Moreno, Bill Twitty, Hector Jacott, Leigh Larson, and coach Ernest Kivisto. (Manuel Huerta.)

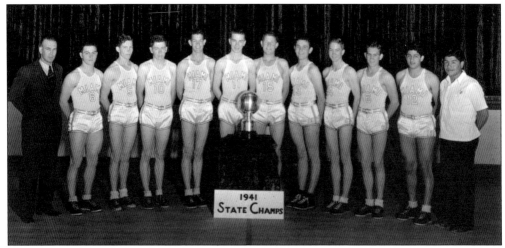

The Miami High School basketball team won the state basketball championship in 1941. Pictured from left to right are coach Earl McCullar, Mack Netterblad, Frank Downs, Frank Bush, Vincent Cisterna, George Cole, Vernon Clark, Nick Saban, Larry Schmich, Sam Lewis, Al Nader, and team manager Florentino Lara. Another player on the team was Manuel Lopez, but he is not in the photograph. Manuel Lopez won the state championship in the high jump in 1940 and 1941. Vincent Cisterna won the state pole vault championship in 1941. (Miami Memorial Library.)

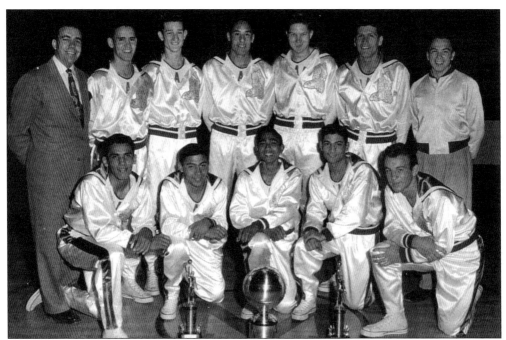

The Miami High School 1951 basketball team won conference, district, and state championships. The team went unbeaten in 27 games, and the players set many individual performance records, as well as team records. Pictured from left to right are (first row) Lupe Acevedo, Richard Vargas, Adolph Trujillo, Elias Huerta, and Andy Rumic; (second row) coach Ernest Kivisto, Hector Jacott, Eli Lazovich, Rudolph Moreno, Leigh Larson, Alfred Lobato, and manager Jesus Romero. (Manuel Huerta.)

Alfonso B. Muñoz (October 31, 1926–March 21, 2007) played football for the Miami High School Vandals. Alfonso served in the armed forces, where he won a boxing championship. After his military service, he played college football. Later, he coached football at Glendale High School in Glendale, Arizona. (Sammy Muñoz.)

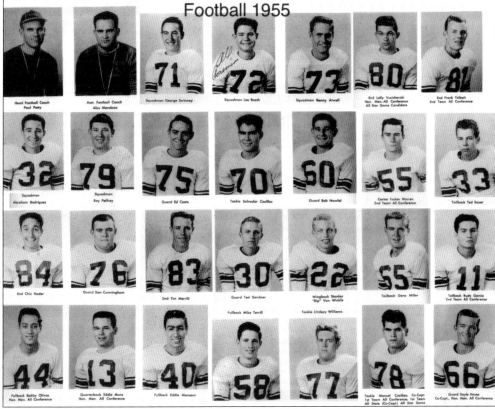

The Miami High School 1955 state football championship team includes, from left to right, (first row) Bobby Olivas, Eddie Muns, Eddie Mansour, Mike Terrill, Lindsay Williams, and cocaptains Manuel Casillas and Doyle House; (second row) Chic Nader, Don Cunningham, Tim Merrill, Ted Gardner, Stanley Van Winkle, Gene Miller, and Rudy Garcia; (third row) Abraham Rodriguez, Roy Pelfrey, Ed Coots, Salvador Casillas, Bob Newfel, Tucker Warren, and Ted Sexer; (fourth row) head coach Paul Petty, assistant coach Alex Mendoza, George Swinney, Lee Booth, Benny Atwell, Lolly Vucichevich, and Frank Talbott. (Manuel Huerta.)

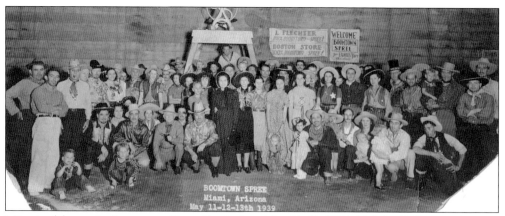

Miami celebrates its Boomtown Spree Festival on May 11–13, 1939. (Eulalio Ballesteros.)

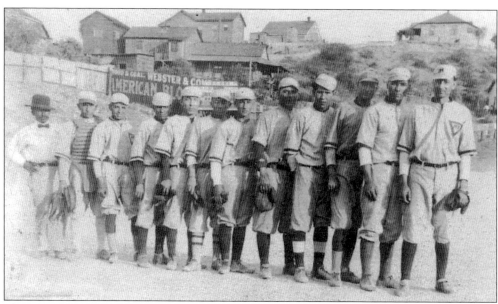

The Mexican American YMCA baseball team competed with teams from California and Mexico in a semiprofessional baseball league featuring games in the Claypool baseball park around the 1930s. (Paul Cruz.)

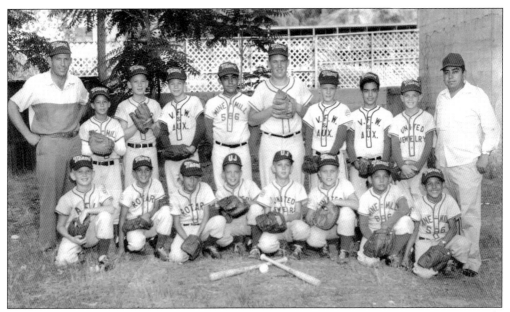

Players on the Miami All-Star Little League team represented Miami at the Casa Grande Tournament, held July 20, 1956. From left to right are (first row) Robert Inbody, Bobby Leal, Ruben Santellanes, Gary Lawrence, Wayne Blake, Jimmy Grizz, Manuel Reyes, and Paul Cruz; (second row) comanager Beal Colvin, Manuel Flores, Harold Montgomery, Hugh Minifee, Alex Chavez, Richard McPhail, Wesley Colvin, Manuel Rodriguez, Garry Hincha, and comanager Tony Sermeno. (Paul Cruz.)

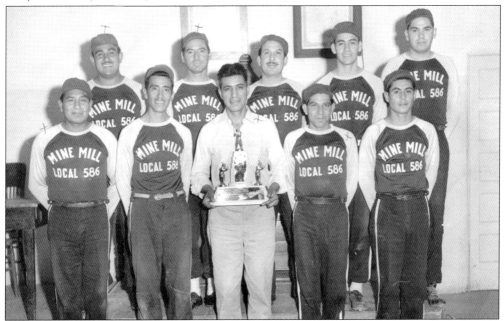

Champions of the Gila County Softball Association in the 1952 season are pictured from left to right as follows: (first row) George Perkins, Felix Garcia, manager Ralph Landa (holding the trophy), Alejandro Campos, and Vicente Valenzuela; (second row) Fidel Montolla, Reymundo Lopez, Feliz Ortiz, Tony Gomez, and Pete Benites. (Catalina Valenzuela.)

Miami women bowlers include, from left to right, Betty Beneteau Rayes, Velma Oliverio Beaver, Jean Beedle Sims, Soyla Pacheco Rivera, and Maxine Ballard Gurovich. The bowling team, sponsored by Inspiration Consolidated Copper Company, competed in the 1960 Women's International Bowling Congress Tournament in Denver, Colorado. Bowling, a popular sport for both men and women in the Globe-Miami area, began in the late 1940s at the Johnny East Lanes on Live Oak and Adonis Avenue. (Betty Beneteau Rayes.)

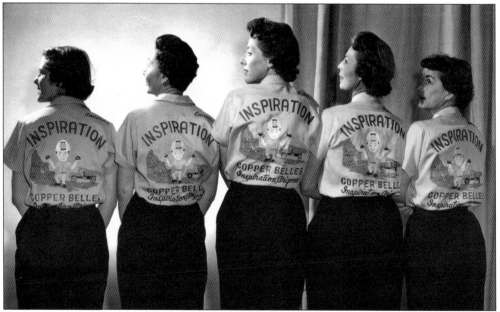

The same women bowlers, left to right as above, are turned around to proudly show their logos and sponsor, Inspiration. In the late 1950s, the bowling activity moved to the Copper Hills Lanes in Claypool with automatic pin setting. State tournaments, held locally for both men and women, created many outstanding bowlers. Plaza Bowl, built in Globe by Louie Ellsworth, served the bowling community until it closed in December 2007. (Betty Beneteau Rayes.)

Miami promoted community sports like Little League, semiprofessional baseball, bowling, and softball leagues. This picture shows the 1968 Miami All-Star Falcons team and coach. From left to right are (first row) Sylvia Rodriguez, Gwyn McGougy, Emily Cruz, Rachel Garcia, and Sue Romero; (second row) manager Al Nader, Elsa Cruz, Sue Rodriguez, Vicki Cruz, Helen Cruz, and coach Eddie Tewksbury. (Paul Cruz.)

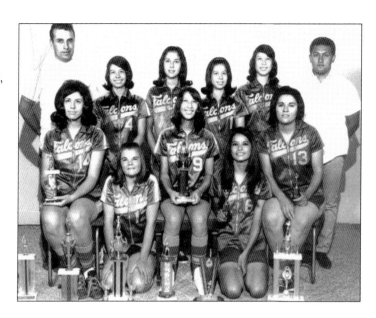

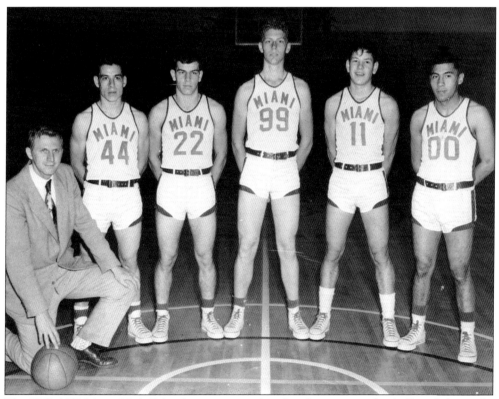

The 1952–1953 Miami High School varsity team played in the state semifinals. From left to right are coach Gerald Jones, Joe Rodriguez, Jim Ceal, Tom Hundley, Sammy Muñoz, and Richard Vargas. Sammy participated in the all-star preparation game at Arizona State College in Flagstaff,. Richard Vargas played quarterback for Arizona State College and later coached basketball for 20 years at Miami High School, where his teams won five state championships. (Sammy Muñoz.)

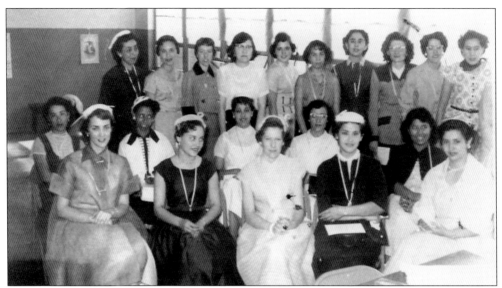

Faithful young women participated in a Day of Recollection at Our Lady of the Blessed Sacrament Catholic Church in 1954. From left to right are (first row) Pat Slack, Mary Ann Flores, Betty Beneteau, Elodia Reveles, and unidentified; (second row) Lillian Baroldy, and four unidentified participants; (third row) Angelita Jimenez, unidentified, Gloria Sanchez, Delfina Venegas, Emilia Almayda, Socorro Castaneda, Mercy Sendejas, Kathleen Carovich, Mary Ortega, and unidentified. (Betty Beneteau.)

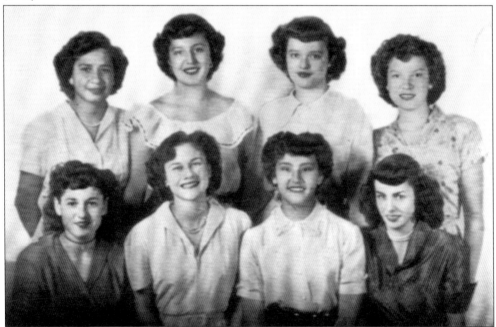

Our Lady of the Blessed Sacrament Catholic Church sponsored an annual Queen of the Festival contest. Young girls sold tickets in competition for the title of queen or princess. The number of tickets sold determined the honor each contestant earned. Pictured from left to right are (first row) Rita Castaneda, Lilly Rivera, Elodia Reveles, and Socorro Jimenez; (second row) Alice Cortez, Sylvia Caplett, Josephine Flores, and Bertha Muñoz. (Lucy Rojas.)

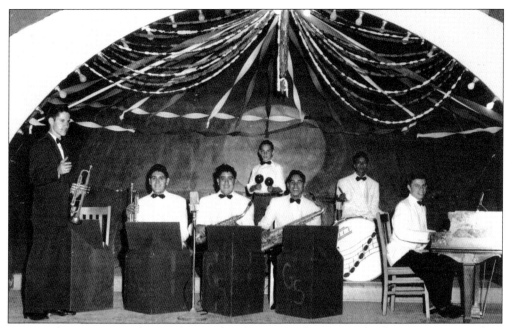

In 1948, the George Sanchez Orchestra played music for dancers on the floor at Miami's Bullion Plaza Ballroom. From left to right are (first row) George Sanchez (bandleader, shown with trumpet), Arthur Bejarano (trumpet), Charles Bejarano (alto saxophone), Chon Canchola (tenor saxophone), and Tony Sanchez (piano); (second row) Joe Sanchez (maracas), and Roberto Reveles (drums). (Joe Sanchez.)

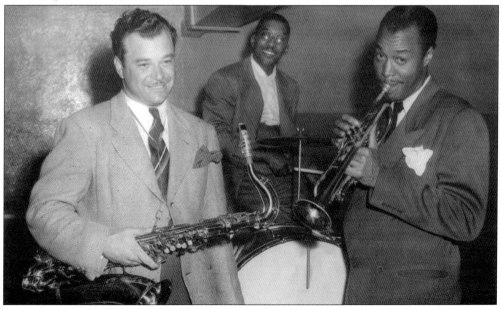

Sipie Martinez, a well-known musician and bandleader for many years, played during an era when dancing excelled as the most popular recreation. Throughout Arizona, most towns supported their music bands and orchestras for weekend dances. Pictured are Sipie Martinez (standing left) and two unidentified musicians. Martinez performed music until July 25, 2008, when he passed away at age 94. (Arthur C. Hernandez.)

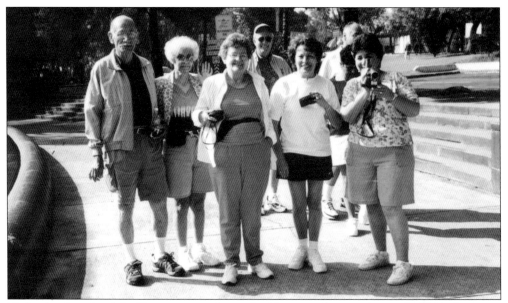

High school teacher John Yanez organized tours for Miami residents each year. In 2000, this group visited Mexico City and other tourist sites, such as Teotihuacán, the ancient "City of the Gods." Pictured from left to right are (first row) Pete De Anda, Socorro Oviedo, Carla, Lily Rocha, and Irene Yanez; (second row) Robert Urban, Nellie Urban, and Joe Rocha. (Santos C. Vega.)

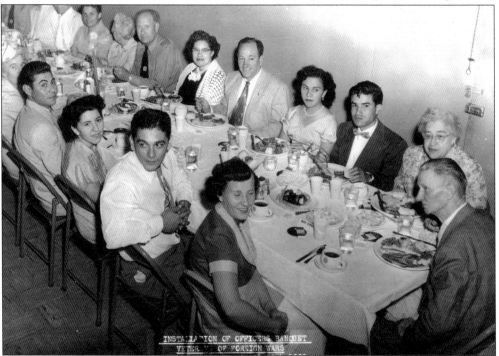

Pictured at a Veterans of Foreign Wars banquet are veteran and active member of the VFW Vicente Valenzuela (at the head of the table), his wife, Catalina Valenzuela (to his right), and next to her are Pilar and Mary Carbajal. Seated across the table from Catalina and next to Vicente are Frances Chavez and her husband, Alex. (Catalina Valenzuela.)

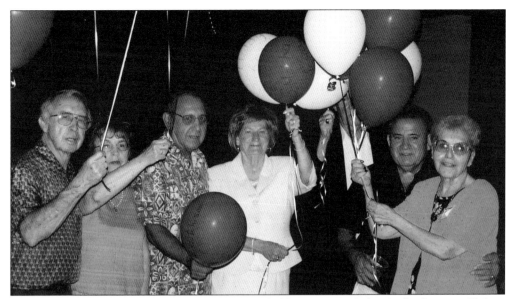

The 1950 Miami High School class reunion was held in Miami's Cobre Valle Country Club at Wheatfields Road in 2005. Usually, fun activities precede a dinner. Pictured from left to right are Ralph Guadiana, Lorenza M. Guadiana, Manuel Trujillo, Vesta Wilhite, unidentified, Robert Castaneda, and Betty Castaneda. Robert and Betty Castaneda have organized Class Reunions. (Santos C. Vega.)

The Miami Sports Hall of Fame (MSHOF) Committee and Board of Directors gathered on Saturday, October 2, 2010, for an outdoor cookout at the Miami downtown park, to chat and have fun before their planning meeting at the Miami Memorial Library. The meeting was to continue the historic work of honoring Miami High School student athletes from 1916 to 1988. Joe Sanchez (left) and Mike Terrill grilled the hamburgers. (Santos C. Vega.)

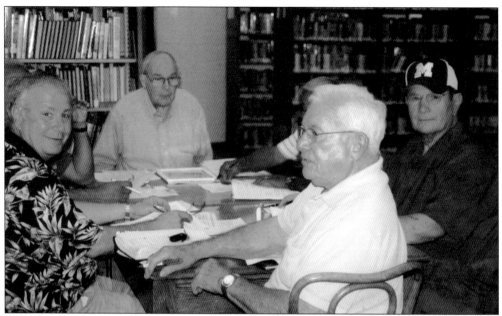

The Miami Sports Hall of Fame Committee meets at the Miami Memorial Library to plan the 2010 MSHOF Ceremony IV Inductees Enshrinement & Honoring of Individual/Dual State Champions. The ceremony was held at Miami High School in Claypool and Miami Memorial Library on Saturday, October 16, 2010. Pictured clockwise, beginning with the gentleman in the center background, are Ed Long, Adolph Trujillo, Mike Terrill, Dewey Mawson, Ray Arrona, and unidentified. (Santos C. Vega.)

The Miami Memorial Library houses the Miami Sports Hall of Fame. The hall of fame, created and designed in 2005–2006 and dedicated in 2007, serves to honor student athletes who excelled in sports at Miami High School from 1916 to 1988. Pictured is the entrance to the hall of fame room and partitions where framed photographs of individuals, teams, albums, and banners are displayed. (Santos C. Vega.)

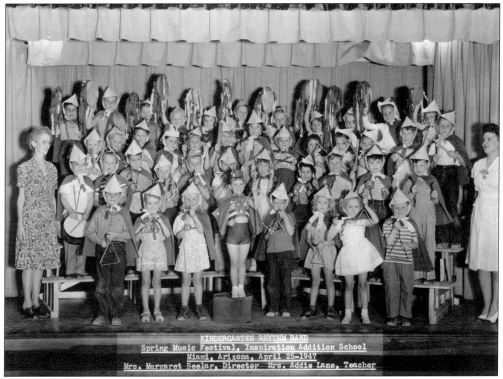

The Kindergarten Rhythm Band of Inspiration Addition School participated in the Spring Music Festival in Miami, held April 25, 1947. Music director Margaret Beelar (left) and teacher Addie Lane (right) appear, but the children are unidentified. (Raquel R. Gutierrez.)

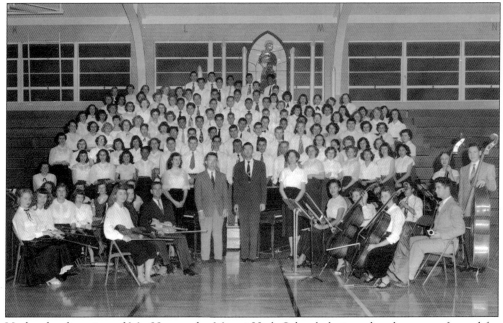

Under the direction of Mr. Horne, the Miami High School choir and orchestra performed for community concerts in the 1950s. (Paul Licano.)

123

A fiesta was held at the Bullion Plaza Cultural Center & Museum, on the grounds in front of what was once the Bullion Plaza School and the Elks Dance Hall Pavilion. Arts and crafts, games, and food booths ring the large space. Music played so those who wished could dance. (Santos C. Vega.)

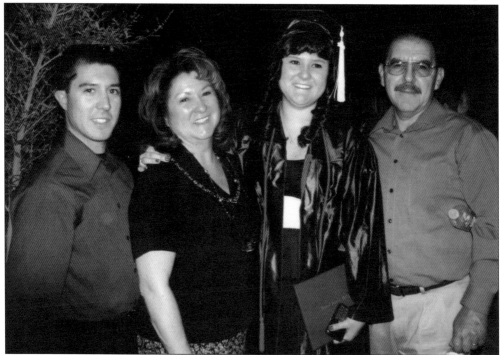

Alissa Valenzuela celebrates her graduation from Central Arizona College on May 15, 2010. In this picture, brother Gabriel Valenzuela, mother Beverly Valenzuela, Alissa, and father Eddie Valenzuela pose on the college campus. All four members of the family attended Miami and Globe schools and work around Miami. (Eddie and Beverly Valenzuela.)

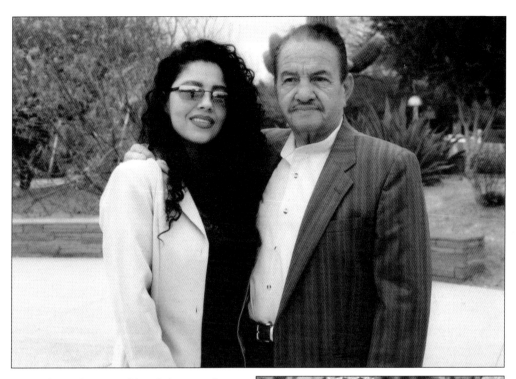

Normalicia Blanco and her father, Anthony Gutierrez, both serve in the Tempe Tardeada Commission. She works for a school in Guadalupe, Arizona. Anthony, born and raised in Miami, played basketball for Miami High School and set individual and state records. He averaged 20 points per game, scoring 1,000 points during his four years of play. He made all-state and all-conference in his fourth year, 1949. (Anthony Gutierrez.)

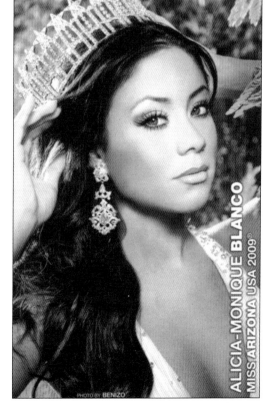

Alicia Monique Blanco, daughter of Normalicia Blanco and granddaughter of Anthony "Tony" Gutierrez, won the Miss Arizona beauty pageant and was second runner-up in the 2009 Miss USA pageant. She graduated from Arizona State University in 2009. (Anthony Gutierrez.)

Lisa-Charisse Blanco, daughter of Normalicia Blanco and granddaughter of Anthony Gutierrez, was an Arizona State University Spirit Squad dancer in 2008–2010 as well as a 2010–2011 Fiesta Bowl Princess. Lisa is majoring in journalism at the Walter Cronkite School of Journalism, Arizona State University. Proud mother Normalicia and grandfather Anthony Gutierrez both live and work in Tempe, Arizona, where they are active members of the Tardeada Advisory Board. (Anthony Gutierrez.)

Lisa-Charisse Blanco (left), 2010–2011 Fiesta Bowl Princess, and Alicia-Monique Blanco, second runner-up in the 2009 Miss USA pageant, visit with Donald Trump in New York City. Trump is associated with the Miss USA pageant. (Anthony Gutierrez.)

BIBLIOGRAPHY

Byrne, Jeri, project coordinator. *Miami Arizona Historic Tour*. Miami, AZ: Globe/Miami Chamber of Commerce, 1999.

Carnicelli, Teri and Rochelle Mackey. *Going Underground: Reflections on Mining Life in Arizona's Copper Triangle*. Superior, AZ: Resolution Copper Mining, 2004.

Horne, Bert, chairman. *Miami's Fourth Annual "Boomtown Spree" May 14, 15, 16, 1948*. Miami, AZ: Miami Community Builders, 1948.

Muñoz, Sammy. *The Summer of '53: A Bullion Plaza Story During the Years of Segregation*. 2nd edition. Miami, AZ: Bullion Plaza Cultural Center & Museum, 2008.

Muñoz, Sammy and Catherine J. Newell, ed. "The Making of a Coach, the Al Muñoz Story, Miami High School Best Athlete Award, 1945." Tempe, AZ: unpublished manuscript, 2006.

Pry, Mark E. *Historic Resource Survey Miami, Arizona*. Phoenix, AZ: State Historic Preservation Office, Arizona State Parks, 1997.

Sotelo, Joe. *Burro Alley*. Apache Junction, AZ: Hispanic Institute of Social Issues, 2006.

www.arcadiapublishing.com

Discover books about the town where you grew up, the cities where your friends and families live, the town where your parents met, or even that retirement spot you've been dreaming about. Our Web site provides history lovers with exclusive deals, advanced notification about new titles, e-mail alerts of author events, and much more.

Arcadia Publishing, the leading local history publisher in the United States, is committed to making history accessible and meaningful through publishing books that celebrate and preserve the heritage of America's people and places. Consistent with our mission to preserve history on a local level, this book was printed in South Carolina on American-made paper and manufactured entirely in the United States.

This book carries the accredited Forest Stewardship Council (FSC) label and is printed on 100 percent FSC-certified paper. Products carrying the FSC label are independently certified to assure consumers that they come from forests that are managed to meet the social, economic, and ecological needs of present and future generations.

Mixed Sources
Product group from well-managed forests and other controlled sources

Cert no. SW-COC-001530
www.fsc.org
© 1996 Forest Stewardship Council

Find Your Place in History.